ABOUT THE BOOK

It is important to teach children different painting techniques and not to confine their means of self expression to painting with brushes.

Roy Sparkes shows that it is possible to complete successful and worthwhile paintings without a brush. He describes and suggests ways of using applicators such as knives, rollers, sponges, rags and sprays, to introduce painting techniques to children.

The six main sections include Finger Painting; Sponge and Rag Painting; Painting with Knives; Painting with Rollers; and Spray Painting. Also included are Technical Notes, a Bibliography and names and addresses of Suppliers of Materials.

A concise and easy-to-read text is illustrated by over eighty photographs of details of techniques and paintings, mainly the work of middle and upper school children to which age groups emphasis is given. However, the techniques and ideas given are nonetheless useful for teachers of all age groups to explore.

ABOUT THE AUTHOR

Roy Sparkes is an experienced teacher and lecturer. He was Head of Art at Slade Green Secondary School, London Borough of Bexley; The Cavendish Comprehensive School, Hertfordshire; and Forest Hill Comprehensive School, Inner London Education Authority respectively. He was Senior Tutor in Oil Painting at Crayford Manor House Evening Institute and Lecturer in Art and Design at Stockwell College of Education. He is now Senior Master at The Downs School, Dartford, where his responsibilities include that of coordinator of the Creative Arts.

Roy Sparkes was a college examiner for the Institute of Education, University of London. He is visiting lecturer to the B. Ed degree fourth year students in Art Appreciation. His own paintings and drawings have been widely exhibited in one-man and mixed shows in London and the provinces, and many are in private and touring collections.

He is author of *Teaching Art Basics*, and *Exploring Materials with Young Children*, also published by Batsford.

PAINTING WITHOUT A BRUSH

ROY SPARKES

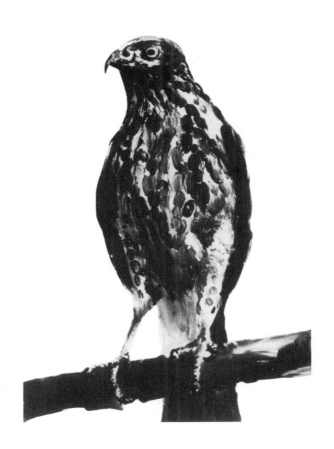

B T BATSFORD LTD LONDON

ACKNOWLEDGMENT

To my family and especially to my mother
and the memory of my father

I wish to express my thanks to all those
teachers, pupils and friends who have helped
in the compilation of this book. My special
thanks are due to — Mr R Broadbent, Head
master, the staff and pupils of The Downs
School, Dartford; Mr D Jamieson for super
vising the photography, Stephen Shott who
carried the brunt of the photographic work
and Kevin Brooks; Mr D Stubbs for his
suggestions for the section on Spray Painting
and for permission to include illustration
of his work; and to Mrs K Doyle for her
careful checking and supervising the typing
of the manuscript.

I am grateful to my family and close
friends who have given encouragement and
have been patiently kind; and to Thelma
M Nye for her advice and wise suggestions

Frindsbury, Kent, 1978 R C E S

Printed in Great Britain by
Cox and Wyman, Fakenham, Norfolk
for the publishers
B T Batsford Ltd
4 Fitzardinge Street
London W1H 0AH

CONTENTS

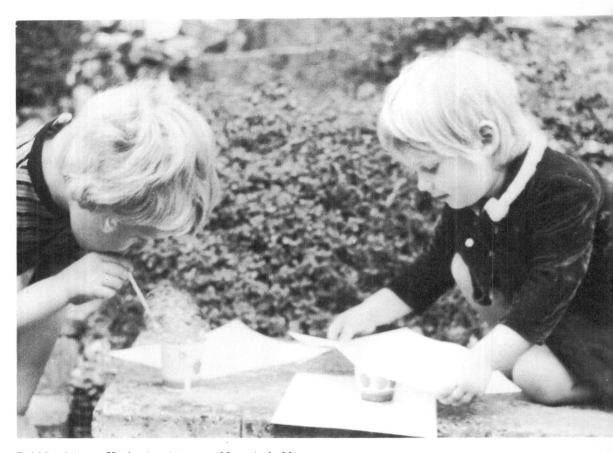

Bubble pictures. Yoghurt pots are used here to hold
the colour mixed with liquid detergent. Neil is using
a drinking straw to blow the bubbles above the
level of the pot. Claire is placing the paper over the
bubbles she has blown to take an impression

INTRODUCTION

The main purpose of this book is to describe and suggest ways of using applicators other than brushes when introducing painting techniques to children in school. There is a need to teach children different painting techniques and not to confine their repertoire for self-expression to painting with brushes. It is not the intention here to replace brushes. They are eminently suitable for painting on all kinds of surfaces, but do not always satisfy the response an individual may wish to evoke. Brushes can be used in combination with some of the applicators described. For instance, to state refined details having used rollers, sponges or spray guns; and to make interpretations from marks made by blowing, throwing, pressing and dripping paint onto a surface. The close relationship between choice of materials and ideas is commented on by Hausman[1] when he states the choice should be with the potential of materials to be used in terms of ideas.

It is possible to complete successful and worthwhile paintings using only the applicators described. Some of the methods will be known already by certain teachers and children. They are re-stated together with suggestions for exploring new ways of using materials. Children should be given the opportunity to explore and make their own discoveries. The teaching of techniques (along with discoveries made by teachers and children and the development of related skills), is seen as part of the process involving children in making decisions about their work. This is particularly important when choosing materials.

Discoveries, by an individual working alone or in a shared activity, and their future use in creative work, will give a sense of involvement with the work in hand. It is at this point that teaching skills will be most in demand to:
1 create onward-going situations, which will include opportunities for sensate experiences;
2 fertilise the interest shown without stifling it;
3 know when to make suggestions;
4 convey the knowledge and experience connected with these techniques.

It has frequently happened that enthusiasm has died when technique has been lacking.

Using the techniques described in this book, it is possible to allow individual self-expression whilst exercising control of the media. All too frequently the two have been divorced in art teaching. This is a difficult problem to resolve, not least because much of the art work being done in school has a tradition, and the teaching is influenced by conventional attitudes. The painting processes discussed here, while they demand control of media, are not steeped in long-standing traditions. Finger painting with a history of its own, by its very nature encourages self-expression, whilst gaining experience and control of media. Whatever difficulties are experienced, they are not of an extent to inhibit individual expression. In most schools it is possible to approach the work in such a way that an adolescent feels he is playing a part in the initial discovery in what can be achieved with the medium. Where a request is made for advice on technique, the teacher should be in a position to give it. The intention in this book is to provide the basis for the teacher to do this or for an individual pupil to gain necessary guidelines to obtain knowledge for him- or herself where it is desirable. In the recent past, the acquisition of skills has been seen by many art teachers as a hindrance to spontaneity yet without it lies the danger of incompetence[2], loss of interest and the opportunity to develop responsible contributions.

The paintings that result from the techniques outlined will be all the more worthwhile if they are the expression of individuals

[1] *Concepts in art education*, (page 41,) George Pappas, Macmillan 1970

[2] *Change in Art Education*, (pages 8 and 9), Dick Field, Routledge 1970

who care and feel deeply about their sensate experiences. This is important in the context of schools, where the need for creative expression exists in a climate of restrictive influences and traditional attitudes which have little connection with Art. This has much wider and important implications in the whole field of art education. The writings of Robert Witkin[3] and Malcolm Ross[4] should be consulted. Their work in the field of creativity and feeling is vital to the future of Art in Education. Dependent upon the climate in school, it may take courage to set up learning situations where children can gain the true value of self expression from the reactions they may make to that expression in controlled and sometimes sophisticated work. The teacher should be ready to talk to colleagues, head teachers, parents and visitors about the work children are doing.

There is a clear need for teachers and interested adults to feel they can communicate with and have some understanding of the work being done in art education. That which is clearly definable is most often that which is accepted in concrete terms and regarded as 'useful' by parents and colleagues. It is ironic that their comments are often only concerned with art work as an end product and not with the learning process involved throughout. But in this context that which is of importance is more difficult to define and explain. There is a need for clarity of purpose, for consultation and communication with others in the field to mutual benefit; and an opening of doors to those who might otherwise turn away.

The teaching of techniques is important. So far, teaching skill and gaining knowledge have often been accepted without clearly defining what knowledge is important within the broad area of art education. Somewhat as a stand against formal approaches, a spate of concern with spontaneity over the last decade has seen art teachers regarding the

acquisition of skills as relatively unimportant and only taught where it is regarded as indispensible. Dick Field[5] states precisely the danger of thinking there is no value in acquiring skill.

The acquisition of skills is two-fold: the knowledge and understanding of the materials; and the gaining of control in using them. This applies to all of the processes outlined in the following chapters. The scope for self expression increases as knowledge and skill become second nature.

Suggestions that certain materials and processes will facilitate spontaneity are not intended to imply that speed is preferable to careful working. See Dick Field on this point in *The Study of Education and Art*[6]. It is often difficult to judge when to impart knowledge and when to teach skills. The teacher requires a sensitive approach to the pupils and their needs, at least equal to the degree of feeling given by the pupils towards the work in hand.

Children of all age groups can explore painting using the ideas given in this book. Although much of the factual content is directed at teaching pupils of secondary school age, younger children will be able to enjoy using the processes described. This will necessitate an understanding of the degree of difficulty related to the capabilities of the children. Most primary school children should be able to produce worthwhile work using spray techniques with spray diffusers and aerosol gas propellents. With increasing sophistication, senior pupils gain satisfaction using spray guns and air brushes. 'Senior pupils' means those in the fourth year and above of their secondary school education. Finger painting has long been established in the creative play of infants. It is rarely used with older pupils. Yet use of particular parts of fingers and hands to state detailed aspects of subject matter and certain atmospheric effects could be a worthwhile and satisfying skill for second and third year

[3] *The Intelligence of Feeling*, (chapters 5, 7 and 8), Robert Witkin, Heinemann 1974

[4] *Arts and the Adolescent*, Malcolm Ross, Schools Council Working Paper 54, chapters II and IV, and pages 48-51 and 56-60, Evans/Methuen 1975

[5] *Change in Art Education*, (pages 8 and 9), Dick Field, Routledge 1970

[6] *The Study of Education and Art*, (chapter 6 Art and Art Education page 145), Dick Field, Routledge 1973

secondary pupils to acquire. Certainly fifth and sixth form pupils have produced exciting work using this method of painting.

As much as action painting can be an enjoyable activity for young children it is most likely that teaching related colour sensitivity and subtleties of colour relationships will be with more advanced work in secondary schools.

When to teach techniques will be dependent on the children's experience, understanding and capabilities using the materials available. It is considered that the main value from teaching techniques will be for those children thirteen plus years of age. This is particularly so in their use of paint with rollers, knives and spray guns. Wherever a method of painting is introduced it should be as part of a structured programme. The acquisition and development of knowledge and skills in a process should be seen as having a positive, onward-looking potential, in a stage-by-stage structure. The content and order of a structured programme will vary according to needs, facilities and materials available. All of the painting processes outlined in this book will have much to offer as part of such a programme.

Reference to the work of artists is made in appropriate parts of the text. What is learnt from contact with such work may feed into the pupils own work in terms of an increased awareness of, for instance, colour, texture and use of materials. It can stimulate worthwhile discussions and help children gain an appreciation of their art heritage. Looking at original works (including visits to local and national galleries) and reproductions (in magazines, postcards and transparencies) will all serve well. Art appreciation is seen as most valuable when it is in relation to practical work in progress.

Visual data of many kinds will be useful for stimulating creative work. Illustrations from newspapers, magazines and books; photographs especially those taken by the children themselves; and filmstrips, transparencies and films will be valuable resource material. It is worth banking subject files of illustrations which may be a pooling of those collected by the teacher and the children. Filmstrips are of more use cut into the separate frames and put into mounts to be used as slides. Wherever possible it is important to provide places for individual reference to transparencies. Hand viewers are satisfactory for this, while slide projectors will have more use in group and class work.

To provide the opportunity of creating art work with brushes and paint alone is to inhibit the chances of emotional and personal development. The individual needs to be able to choose the medium he feels will most facilitate the expression and control of his feelings. The disciplines of the media on an individual's attempt at using it, exercise a control over his expression. In this context it is considered important to include the opportunity of teaching and learning a range of painting techniques. By the time a pupil's secondary school career is coming to an end he should be in a position to express his feelings and ideas with confidence and a degree of technical control. Such control may include traditional attitudes and processes, but should also include a natural response and development of a realisation of his own feelings and ideas in using the chosen media. The latter will most probably come from experimenting, responding, discovering and organising, with guidance where necessary. What the child learns in the process of working is often of more value than the end product produced. This is just as important for senior pupils as it is for young children.

While working with the suggestions given in this book, the comments made above should be kept in mind. Experimentation will be important. Much can be learnt, even from failures. The learning situation at any one time may feed into future work. But with all of the ideas suggested here, full self-expression *is* possible using the equipment in a controlled situation. This can lead to an awareness of personal responsibility, a sense of personal control over responses, to be made not only in the art studio but in life in general.

TECHNICAL NOTES

Additives

All manner of materials have been used by artists in their pictures. The Cubists, for example, when concerned with collage techniques introduced onto the picture surface everyday materials, such as newspaper, cloth and cardboard. Kurt Schwitters carried this further, including in his compositions objects that might normally be regarded as waste, such as bus tickets. Fautrier combined liquid paint and plastics to build a ground for his series *Hostages*, 1945; and Alberto Burri has used sacking with areas of brilliant colour. The line dividing sculpture and painting is thin and, at times, a broken one. Painters have projected their picture surfaces into relief. Paul Klee experimented with glue and plaster to form a ground on which he painted with brilliant colour. Dubuffet created his ground from various materials including white lead, plaster and oil paint with additives such as sand and coal dust. On this background he often used a *sgraffito* (Italian for 'scratched') technique. Robert Rauschenberg has built out surfaces into relief, integrating screen printing techniques with the use of waste materials. All of these processes are worth experimenting with. The term 'Matter painting' is often used to describe paintings which involve thick and varied media, examples of which can be seen in the works of Dubuffet and Tapies.

It would be sensible to begin with the accessible, ready-to-hand materials. The following could be tried:

Dry powder colour sprinkled onto wet paint or a pva binder. The granules of powder will contribute to rich and interesting surfaces.

Soap The addition of soap can help to control the painting of water-colour washes. It will soften the colour values. A good method is to mix the required colour first and load the chosen applicator with it before touching the soap for mixing. The mixture will not spread as easily as pure, water-based media. Since soap has adhesive properties it is difficult to remove colour that is mixed with it.

There are two main forms:

(i) Block — load the applicator with colour before touching the soap with a rubbing motion;

(ii) Liquid — mix the chosen colour with water then pour a little soap into it, six parts colour to one part soap.

This can be used in making 'bubble' pictures or designs. Place a little of the mixture into a beaker or jar (approximately 10-12 cm high). With a drinking straw held in the mixture so that one end is just below the surface blow into the liquid until bubbles rise over the lip of the beaker. Remove the straw and place a clean sheet of paper (cartridge or newsprint) over it to take an impression from the bubbles. This can be repeated as often as is necessary to produce a satisfactory design which can be kept for its own qualities or developed with other media such as pen and ink.

Starch The marks peculiar to particular applicators will remain when using colour mixed with starch. In school it has often been used for finger painting. The more starch used in the mixture, the lighter the shade and more opaque the colour will be. It is advisable to use the mixture on a strong inflexible surface such as hardboard or thick card. On a flexible surface the colour will tend to crack. This can be obviated by mixing a few drops of gum arabic with it.

Cooking oil Mixed with tempera colours it will provide a smoother consistency which can be painted onto sugar paper, card or board. It provides a different, interesting textural quality.

Sand There are different kinds to choose from or combine, different textures from coarse to fine, and colours such as yellow, brown, grey and white. There are three main ways of using it:

(i) To enrich the textural possibilities of

painting media. Mix the sand with the chosen powder or liquid tempera (add a little pva binder to increase adhesion); emulsion and oil colours could be tried. The mixing can be done with a palette knife or a plasterer's trowel on a mixing palette. Since the paint will now be thick and heavy, it is advisable to work on a firm ground such as card or board (thinner consistencies could be tried on cartridge paper). The paint/sand mixture is best applied with a spreading action;
(ii) 'Marmotinto' Natural sand sprinkled over a drawing that has been made with an adhesive (a pva binder is advised) on paper or card whilst the binder is still wet (see (iii)). It can be developed with paints or using pastels, crayons or felt tip pens;
(iii) 'Marmotinto' Sand painting. Similar to (ii) except that the sand is coloured prior to use. This can be with inks or mixed with paints (see (i)). Once the sand has been sprinkled over the adhesive, shake or pour off the excess sand into a suitable container. Sand that remains held by the adhesive will take up the directions of the drawing. Subsequent applications with different colours can be made once the adhesive has dried.

Children will enjoy trying this method of picture making. It is a well known art form in the Isle of Wight. The emphasis is with the sand but it moves into the sphere of this book as soon as it is mixed with colour.

There are many other substances to be tried as paint additives. Flour, cold water paste, plaster, saw dust and wood shavings are but a few of the possibilities that could be tried in the classroom.

Glazing

The application of successive layers of transparent or translucent colour usually applied when the previous layer has dried. It will be that much more effective, the lighter and more resilient the colour of the underpainting. The darkest layers of colour are the last to be applied. (This process is the opposite to *scumbling*. See page 17).

Impasto

This is thickly-applied paint and often used towards the end of a painting process to state certain details and highlights. Some fine examples of this can be seen in Rembrandt's paintings for example his *Portrait of Jacob Trip* and *Woman Bathing*, both in the National Gallery, London.

Loaded (with colour)

The amount of colour on an applicator (necessary for a particular part of a painting to be treated or to the capacity of the applicator).

Painting media

Water-based media Any pigment or painting media that is soluble in water.

Water-colours — transparent These are usually available in tablet form or tubes, though certain makes come in bottles. Artist's quality tends to be expensive; student's colours are cheaper. The tablets of colour are most often seen in water-colour boxes the lids of which form useful mixing trays. They have only limited use for the techniques described in the following sections.

Transparency will be most effective against a white picture ground, since it will reflect most light. The eye perceives colour produced by the light passing through a layer of paint to the white ground, which reflects it back through the paint to the eye. The white of the ground, (usually paper), will be the lightest area in a painting. Colour is lightened and thinned by adding more water. A direct approach is usually the most successful, with details added towards the end of a process. Too much over-painting causes loss of colour brilliance. However an effect similar to that of glazing with oil colours can be achieved by painting in layers of transparent washes — each layer of paint should be dry before the next is applied.

Water-colours — opaque (gouache) The addition of chinese white or chalk will make

transparent water colours opaque. A gum medium is added as a binder. To lighten opaque colour, white is added rather than water. Black (which is not usually used with transparent colours) will help to neutralise contrasting areas of opaque colour. It should be noted that black will not only darken colours but can also change the colour property. For instance, yellows appear as greens and reds become browns. (This is due to the addition of blue pigment in order to produce a 'cold', dense black rather than a brownish one). When mixing opaque colours, it is important to allow for their drying much lighter than they appear when wet.

The cleaning of applicators after use with opaque colours should include washing with soap. This is to ensure all the gum content of the media has been removed.

Working with a water-colour on wet paper can be worthwhile. Apart from the interesting imagery as the paint flows or spreads into different colour mixtures and shapes, the paper will mark more easily when wet. Although such a mark will be difficult to remove it can become a worthwhile process requiring speed of thought and action since the paper will dry quickly. A mark made on wet paper breaks the surface and causes the paper to become more absorbent. When the colour is applied it will remain darker where the paper surface has been broken. There are two main methods:
(i) Apply a colour wash then scratch the surface by drawing into it for instance with a pencil, cocktail stick, finger nail, or a palette knife;
(ii) or draw onto the wet paper before applying colour.

Tempera colours These are in use in most schools in powder, liquid or paste form. They are easy and convenient to use and cheaper than oils without having the same colour intensity and flexibility. Powder colours are preferred to ready-mixed colours since they encourage children to do their own mixing, particularly secondary and tertiary colours, and facilitate the experience and understanding of colour properties and consistencies. Their granular nature can be useful for different textural qualities.

Liquid or paste tempera colours stay bright and clean after mixing. The tendency for temperas, especially powder colours, to dry flatter and duller than when wet and to have a slight chalky appearance can be alleviated by mixing them to a creamy consistency (that of yoghurt is usually thick enough). They are fast drying; and the absorbency of paper surfaces increases the drying rate. This can be an advantage in school, making it possible to work on a painting for a longer time in any one sitting. But a disadvantage is less opportunity to make alterations or corrections. Once colour has been absorbed into the paper surface it is difficult to remove — a damp cloth or sponge will remove some.

Ready-mixed liquid colour is suitable and reliable for most of the work suggested in this book. Children should be encouraged to develop their own colour sense by experimenting with mixing colours. Liquid colour is useful for painting with fingers, sponges, rags and can be used with spray guns.

Poster colours The already considerable opacity can be increased by the addition of white, if required, when overpainting. They are usually sold in pots or tubes. A knife is useful to take the required amount of colour from a pot. Solid cakes or blocks of poster paint film is often thin. Valuable time and spontaneity can be lost whilst 'working-up' enough colour on the block and leads to a wearing down of sponges and brushes. The pots of paint are the most easy to use and keep in good condition.

The paint can be spread in different thicknesses. Transparency can be achieved by thinning colours with water. In this way they are useful for planning a composition. Ideas can be stated on the picture ground fluently and quickly. Later stages should be thicker. As soon as the colour is dry further applications can be made. For an intense colour, the last layer should be thicker than the previous application. Poster paint will not crumble or crack as easily as liquid tempera when applied impasto. It

should be noted that overworking with an applicator can disturb paint already applied. It is best to think first and use a direct application of paint, placing it where desired and leaving it be.

Colours dry lighter and may appear chalky where white has been mixed with darker hues. Allowances should be made for this when mixing. Poster colours can be used with comparative ease. They are inexpensive compared with oils. There is a wide range of colours available. Try the following as a good basic palette to begin with:
Brilliant blue — brilliant red — vermilion — yellow ochre — lemon yellow — black — white

Acrylics There are different trade names such as *Polymer* and *Cryla*. They are plastic emulsion paints. In their manufacture a binder is used instead of a gum which makes them waterproof in drying. Once dry they cannot be dampened and mixed with further layers of colour. They cannot be redistributed on the picture surface. It is advisable to dampen an applicator before loading it with colour. Acrylics have a tendency to dry in a film and may cause an applicator to stiffen in time.

They dry more quickly than oils and the drying rate is increased the warmer and dryer the atmosphere. Heavy *impasto* will dry in three to four hours while thin layers dry in minutes. They can be kept moist by spraying water over the surface. It is preferable to have ideas clear before starting to work since it is necessary to work quickly.

Acrylics can be used for:
1 Transparent films of colour by diluting them with water. This facilitates glazing which is easier and quicker with acrylics than with oils. An acrylic glazing medium can be purchased which makes the work easier still. It will also facilitate application of thin collage material;

2 *Impasto* effects if they are mixed thickly. White added makes them opaque;

3 Interesting textural effects. Paint surfaces can be built into relief and the textures developed using a variety of applicators such as knives, spatulas and brushes. This is made all the more interesting when an acrylic modelling or extender paste is mixed with it. Similar to the consistency of putty it facilitates thick and rich textures.

Acrylics are usually sold in tubes or jars. Since the paint dries fast, it is difficult at times to get a reasonable quantity from the tube, try using those produced in jars. It tends to remain fresher in the jars (lids must always be securely fastened after use).

Acrylics can be used on most surfaces including card, hardboard, plaster and canvas, whether sized and primed or not. Manufacturers make a white primer available. *Rowney Cryla White Primer* can be used on paper, cardboard, hardboard, plastic, wood and fabric. Fabrics can be rolled without the primer cracking. The paint is flexible whether it is thin (transparent) or thick (opaque).

Since acrylics dry matt, a plastic-based varnish is available which will give a gloss finish if desired (it is considered that a varnish is rarely necessary). An alternative would be to thin colour with a plastic medium instead of water, then it would dry with a gloss.

Although acrylics satisfy purposes which depend on speed of drying and water resistence they are not likely to be in general use in school. They are more expensive and difficult to use than tempera colours. Nevertheless, a basic palette might include:
Titanium white — black — cadmium yellow light — yellow oxide — chromium oxide green opaque — ultramarine — burnt umber — cadmium red.

Aqua pasto Winsor and Newton manufacture this colourless gel which can be mixed with water colours. It is.
1 easy to use with a painting knife;
2 transparent whatever thickness is used;
3 re-workable by wetting it after it has dried.

Emulsion The household variety of plastic emulsion paint is usually sold in tins. It can be worked with knives, brushes, rags or rollers (sponge rollers are usually the most suitable). It is similar to other emulsified paints but it is not always waterproof when dry (check manufacturer's instructions).

Oils Oil colours should be used on a specially prepared canvas, board or paper. The surface of the ground should be coated with size before applying a primer. This will make the surface non-absorbent. Two coats of primer, painted in opposite directions to each other, provide a well integrated picture ground. If a primer is not available, emulsion paint or white undercoat will serve.

The surface of the ground is usually grained to prevent paint from slipping. The smooth side of hardboard can be rubbed with sandpaper before applying the white primer (if preferred the primer surface can be roughened). Surfaces most commonly used with oils are:

Paper treated with size. Some wallpaper offcuts are suitable — use the reverse of washable and vinyl papers
Oil painting paper (sometimes called canvas paper) — sold in sheets or packets
Primed hardboard
Canvas boards
Canvas — from fine-woven to rougher-textured hessian — stretched and primed
Of these, hardboard and the papers are the most likely to be available in school with hardboard providing a durable and reliable surface.

Artist's quality oil colours are the best. *Georgian* colours by Rowney and *Greyhound* colours by Reeves are good quality (or their equivalents from other companies); and student oil colours will be satisfactory for work in school if the foregoing are not available. (See the notes on 'Palette' for choice of colours).

The three main thinners or solvents for oil colours are.
1 Oil — usually linseed. It is advisable to keep the use of this to a minimum. There are two main dangers of excessive use:
(i) a greasy surface will result;
(ii) colour will darken with the absence of light.
2 Pure turpentine. It prevents too much sheen (possible with oils). If used excessively it can give a dry, chalky appearance, reduces colour brilliance and the powers of adhesion of successive layers;
3 A mixture of pure turpentine and linseed oil. This is called a 'medium' or 'gel medium'. It can be mixed with the colour to produce thin glazes; and it speeds drying by approximately half the time.

Oil colours normally take two to three days to dry (oil oxidises and develops a skin). Very thick paint will take much longer. It is correct to paint either over dry paint or into wet paint. It is not advisable to paint into sticky or partially dry paint.

Picture grounds or painting surfaces
(sometimes called 'supports')

Newsprint This has only minimal use as a surface for painting. It could be used to make impressions on with sponge or rag, but any attempt to move colour across the surface will almost certainly result in tearing. With runny paint it soon becomes saturated. Its flimsy nature causes thick paint to crack. In school it is useful for taking impressions of finger paintings and monoprints.

Cartridge A versatile paper which can be used for most of the projects in this book. There are three main surface qualities to choose from. In increasing order of roughness they are: hot pressed, cold pressed and rough. To paint with oils, cartridge paper must first be given a coat of size or a pva binder thinned with water (see the notes on 'Painting media — Oils'). The smoother the paper, the stronger the colour will remain after drying. Try providing the opportunity of working on a paper approximately 140 grammes per square metre (often written as g/m^2) in weight. A really good quality cartridge paper will not be less than 170 gr. Hot pressed paper is hard and not very absorbent. Paint can be removed more easily from the surface of smooth paper by wiping either while the paper is damp or when colour is dry using a slightly dampened cloth or sponge.

Good quality water-colour paper tends to be expensive. Try using water-colours on a

softer paper that has a rough texture. For most work, the weight of the paper should not be less than 95 gr. It is worth the expense to experience painting on *hand-made papers*. But these are more difficult to purchase and the expense restricts their general use in schools.

Sugar paper There are various thicknesses, textures and colours from which to choose. It is particularly suitable for painting with tempera colour in powder or liquid form. For the suggestions for painting described below, the paper weight should not be less than 95 gr.

Canvas It is not usually practical or economic for general use in school. Smaller groups of senior pupils may enjoy the chance to paint on it. Alternatives might include boards with a canvas texture such as *Daler board*. Oil colours may be applied to canvas or canvas board with knives or brushes. The type of canvas will depend on individual preferences, from the finest cotton to coarser hessian. Those bought on stretchers are usually ready for use; otherwise the canvas once stretched will need a coat of size followed by a primer.

The surface can be prepared for water-based media by applying a mixture of powdered starch, water and a few drops of gum arabic. If transparent water-colours are used the texture of the grain of the canvas will feature much more in the final effect. Acrylics can be used more effectively on canvas than on papers.

Boards In addition to *Daler board* mentioned above, any of the following could be tried: hardboard, chipboard, essexboard, and plywood. Of these, hardboard is the most practical for use in school. It can be used for all the methods of painting mentioned in this book. It can be used without priming, but it is usual to coat it with white primer, tins of which can be purchased from most good art suppliers. Offcuts are useful and can be further cut to shape and size. The smooth side is the most serviceable and easiest to work on. The textured side can soak up too much paint if you are striving for economy.

Chipboard and hardboard are also useful as drawing boards for 'stretching' papers before painting with water-colours (see page 20 in the section on 'Finger painting').

Coloured grounds They will influence colour when transparent or translucent paints are used. Grey and black will tend to neutralise colours. The brilliance of transparent colours will be reduced when painting on a dark or black ground since it will absorb more light than white paper. It may be desirable to have a colour influence throughout a painting. This can be achieved by using a coloured primer or undercoat. (It can also be achieved by mixing quantities of the chosen colour with other colours on the palette before use. Good colour harmony is obtained in this way using a 'life-blood' colour).[1] The colour of the ground is less important where opaque colour is being used or where paint is applied *impasto*.

Transparent surfaces Perspex and glass are the most likely to be used in school for painting. An advantage is that a sketch or plan can be placed under and then seen through the painting surface without any need to trace. Oils can be used on glass and most water-based media mixed with a little pva binder will work successfully too. The binder is advisable when painting on plastic surfaces for improved adhesion.

It is possible to work on both sides so that one complements the other. The 'front' can be painted with foreground details, of for example a landscape; and the other side with middle tones and greys. The 'back' of the transparent sheet can be painted at any time and not necessarily at the outset as is often advised with most subjects when using water-based media.

Other surfaces Try painting on:
1 Wallpapers — some of the stronger vinyl papers are capable of holding oil colour as well as being interesting to use with water-based paints;

[1] *Teaching Art Basics*, (page 39), Roy Sparkes, Batsford 1973

2 Wrapping papers. Mainly for water-colour work,

3 Blotting papers — try the different grades. They will absorb colour quickly. Spraying paint can produce interesting results. Colour areas can be interpreted and developed with felt tip and ball point pens;

4 Mirrors (see the notes on 'Transparent surfaces');

5 Fabrics. Either stretched on a frame or glued to a board using size, emulsion paint or a pva binder. There is a wide range of textures and densities to try.

Palettes

Storage Plastic palettes with six or nine wells can be stacked easily and are useful for storing dry powder paint.

Mixing A flat tray or tile is preferable. Possibilities are *Formica*, ceramic tiles, metal sheets, glass, perspex, plywood, an old dinner plate or a disposable paper palette (waxed or greaseproof papers could be used for oils or acrylics. They are sold in sheets or as strip-off pads). *Formica* (an offcut) will make a good general purpose palette. Wood will have to be sealed with varnish. Where possible use an appreciable size especially when working with rollers, eg. 30 x 40 cm.

Colour palettes

The range of colour will depend on individual preferences related to the demands of the work in hand. Children should be allowed a choice which will help them develop colour awareness and make colour mixing more exciting. With practice, preferred colours will be determined and added to a basic palette. To start with, the following lists will provide the possibility of much successful painting.

Tempera colours — and other water-based media (see the notes on 'Painting media' for lists of poster and acrylic colours).

Vermilion*	Burnt umber*
Crimson	Yellow ochre
Brilliant yellow*	Black*
Ultramarine*	White*
Viridian	

The list could be reduced further, if necessary, to those colours marked with an asterisk. The range can be gradually developed with subsequent work.

Oil colours sold in tins or tubes. Rowney's *School of Art* colour in half litre tins is good value for use in school where it is expected that a fair amount of oil painting will be done.

There are different tube sizes, it would be sensible to buy larger sized tubes of those colours likely to be more used. The following would be a good palette to begin with. Recommended tube sizes are in brackets. Flake or titanium

white (14)	Cadmium red (8)
Yellow ochre (8)	Cobalt blue (8)
Chrome yellow (8)	Ivory black (8)

Most likely additions are: Ultramarine — lemon yellow — viridian — burnt sienna — vermilion — raw umber. It is important to use non-toxic colours in the classroom. Check manufacturers instructions before purchasing.

With household emulsion and oil paints, a different range of names is given to the colours available. Selection should be made after consulting a manufacturer's colour chart.

The arrangement of colours on the mixing palette can be important to a good, ordered system of working. Place warm colours to one side of white with yellow next, going to reds and browns; and cold colours on the other side including greens, blues and black.

Primer

Priming makes a surface non-absorbent and receptive to paint. It is usual to apply a white coat which gives greater luminosity to colour painted over it. Boards are the most likely paint supports to need priming, when it is better to give two or three coats painted in opposite directions to each other, applied when a previous application has dried. It can be applied directly to the board surface or over a coat of size.

PVA binder

Polyvinylacetate is on the market under a number of different trade names such as *Dufix*, *Woodworking Adhesive* and *Marvin Medium*. As well as being a versatile adhesive, it can be mixed with colour to extend the range of painting possibilities. References are made to it in the sections on various techniques. It has often been used mixed with tempera colours to give them something of the consistency of oil colours. In addition, it acts as a seal to absorbent surfaces and can be used as a protective agent.

Scumbling

The use of an opaque layer of paint moved lightly across a painting ground or, more usually, over a painted surface, so that the colour is caught and held by the projections in the texture, without entirely obliterating the lower layer. This is most successful when application of paint is made with a knife or brush.

Sgraffito

A process whereby one surface is removed to reveal colours of another surface underneath. It was used in Renaissance times in Italy to describe a process in pottery decoration and it is still used in European countries for decorative purposes. A stylus or some other pointed instrument is used to scratch away the top layer of colour. The type of paper used will effect the result:
1 Thin papers — only a limited amount of scraping is possible;
2 Soft papers — yield and lend themselves to scraping;
3 Grained surfaces — scratching removes only the uppermost parts of the grain;
4 Rough surfaces — are more easily damaged and scraped away.
Boards and plastics such as perspex will provide durable surfaces, and most cartridge papers provide adequate surfaces for sgraffito.

Varnish

Basically three main uses:
1 To protect painted surfaces. Copal is a hard resin varnish which will give good protection;
2 To revitalise colour. Copal varnish or thicker and softer resin dammar varnish could be tried.
The painting must be thoroughly dry before varnishing,
3 Mix with painting media before application, as part of the painting surface. Only small quantities of varnish should be used in this way. It can help to enrich textural qualities in oil painting, for example, in the work of Keith Vaughan.

Oil painting should be left at least six months to dry before applying varnish. Do not varnish on a damp day, 'blooming' may result. Allow the varnished surface to dry in warm conditions but do not expose to direct sunlight. Protect newly varnished surfaces from dust and always apply the varnish with a *clean* brush kept specially for the purpose.

It is better to spray water-colours with a fixative which can be purchased in aerosol cans or in bottles with a mouth spray diffuser. Acrylics should not need varnishing. If desirable an acrylic medium could be used (consult manufacturer's catalogues for details and trade names).

FINGER PAINTING

Finger painting is usually regarded as an enjoyable and spontaneous activity for young children. It can be seen in use in most primary schools where it is considered to be of value in helping children gain control over motor skills and confidence in self expression. Very rarely has it been developed to an advanced sophisticated level. Yet finger painting has a history dating back to primitive man; it has been developed to a high degree of control in China; and can be seen in various forms such as monoprinting. It is a versatile process and can be used to answer most demands that an artist may meet.

The term 'finger painting' is misleading if it is taken to mean only the fingers are used. Many different parts of the body may become applicators in the process. Most of the effects that will be needed can be achieved using parts of the hand and forearm. The fingers and finger nails will do most of the work especially when stating details. The palm and in particular the heel of the thumb are more suitable for painting larger areas.

The educational benefits of finger painting are many. It can be of great value in the physical, emotional and intellectual development of the individual. Children can explore large and small arm movements and delicate finger movements, at times using both hands equally. The whole body can be involved in the activity. It is conducive to enjoyment and success for all children. But it is of particular value to those with weak control and co-ordination of manual movements.

When a child realises that the images made can be easily wiped off and a new start made, many tensions and inhibitions are also removed. The activity may help the individual to work off pent-up feelings and surplus energy. The 'instant success' that finger painting can give the young child can lead to self confidence perhaps for a person of an otherwise nervous disposition.

The intellectual values of finger painting are well known. It can be used as an aid to colour recognition. With children encouraged to talk about their work, it is an aid to language development. Many an otherwise introspective and quiet child has become talkative and forthcoming when describing an achievement in finger painting.

It is possible to gain such control in the process of finger painting that adults as well as children can express highly sophisticated ideas. The finest of details and broadest of areas can be stated with reasonable ease and with a high success expectancy. It is arguably the most direct of all the painting processes. Intermediaries such as brush, knife and sponge are discarded. Their inherent demands are no longer inhibiting to the beginner who may have a long way to go to gain the skills necessary when using painting implements. A precedent is not being set by putting brushes to one side, if only for a moment. The earliest works of art in the Ice Age were lines drawn with fingers in damp clay, examples of which have been found at Altamira, Spain. Hand prints can be seen in the cave paintings at Pech-Merle in France. Evidence of finger painting has been found in Aboriginal wall paintings; and the Chinese have developed it to a fine art, often painting on silk — the work of Ching Isao a Chinese painter of the eighth century AD includes both figuratif drawings and symbolic graphics. Nevertheless it is not the intention here to diminish the pre-eminence of the artist's brush as a paint applicator. The main motive is to encourage anyone who has not tried finger painting to share the enjoyment it has to offer and the sense of achievement gained from completing a composition in this method.

The place of finger painting in Art Education is due not least to the work of Ruth Shaw who introduced it to the children she taught in the 1920s. She exhibited the children's work in America. Her book, *Finger Painting* written in 1938, records the reactions of the children to finger painting. Different authorities have used finger painting for different purposes. It has been incor-

The edge of the little finger has been used for the repeated motif at the bottom left and at bottom centre, this time with thinner, more liquid paint. The very fine lines were made with the edge of a finger nail dipped into liquid tempera colour. Suggestions of cloud, vegetation and broad areas of land and sea can be made using the heel of the thumb

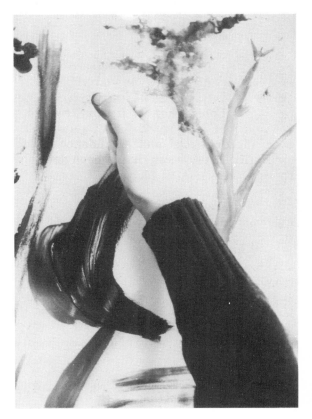

Detail from the upper portion of the previous illustration. The broad, dynamic marks were made with the clenched fist. The linear marks to the right were made with the tip of the index finger. The soft ball of the finger was used for the smaller, closely-grouped marks

porated as a pre-writing activity using the rhythmic patterns in the Marion Richardson approach to handwriting.

Finger painting can be attempted with the minimum of equipment. Some form of protective clothing is advisable.

The working surface should be smooth and non-absorbent to allow ease of manipulation of the paint. *Formica* is a good surface, either a formica-topped table or an off-cut. It is easy to wipe clean when it is not intended to keep a painting. Should a record of the painting be wanted, a monoprint can be taken by placing a sheet of newsprint or cartridge paper of suitable size carefully over it. Hand pressure is enough to take a print. The paper should then be lifted gently away from the painted surface to avoid smudges. Other suitable surfaces are hardboard (after it has been sealed with a coat of varnish or size) and perspex (expensive, but an off-cut could be used). Where it is intended to keep the finished painting on a plastic sheet, the paint can be given the necessary adhesive quality by mixing with it a little polymer medium or a pva binder. This need only be one part medium or binder to five parts paint. It is important to preserve the manoeuvrable consistency of the paint and a larger quantity of medium would begin to restrict this.

Hand-made papers, such as the best quality

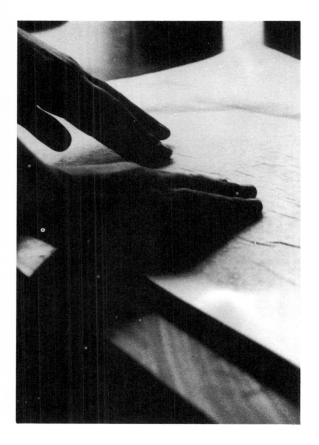

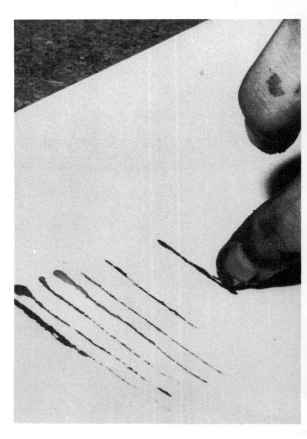

Light finger pressure over the newsprint is sufficient to take a satisfactory monoprint from the finger painting. Lift paper carefully to avoid smudging

A finger nail used for fine linear qualities

Japanese, are exciting surfaces to finger paint on. In school, cartridge and sugar paper are the most likely to be available, with the most satisfactory and worthwhile painting being accomplished on the former. Hot pressed cartridge paper is recommended because it is less absorbent than other varieties. Sugar paper has been used in some interesting work despite its more absorbent nature. It may be worthwhile 'stretching' the paper before painting, to prevent it warping when it becomes wet. Soak the paper briefly in clean, cold water. Place it onto a clean drawing-board, removing surplus water with a clean sponge. Seal the edges of the paper to the board with brown gummed paper strip making it air tight. As the paper dries it contracts and becomes taut. This ensures a good, smooth surface to work on. The

painting can be easily removed from the board using a trimming knife and a straight edge.

Powder paints mixed with water and starch, cold water paste or *Polycell* is suitable when finger painting. It is important to use a non-toxic medium. With children a water-based paint is advised. Alternatives to the powder paint mixture are ready-mixed liquid tempera colour (add a little cold water paste or *Polycell* which acts as a stiffener, retards the drying rate and produces interesting textures) and finger paint prepared by manufacturers for the purpose. The powder paint mixture is cheaper and although it is safe to use, it tends to stain and the consistency is sometimes uneven. The specially prepared finger painting colours, which can be purchased from most artists' suppliers, have a

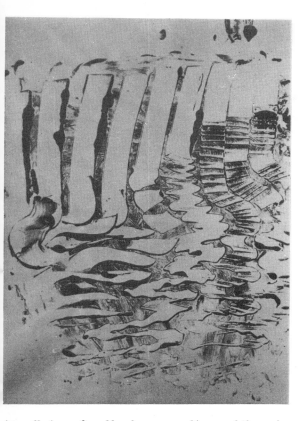

A small piece of card has been moved/scraped through the paint. The lower half suggests water movement

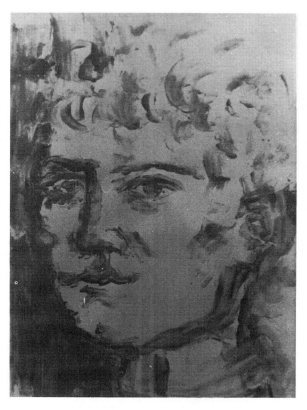

Portrait by Christine Maybank, mainly using the tips of the fingers

smooth consistency, a variety of colours, are highly soluble and can be easily cleaned off the skin and work surfaces with water. They are non-toxic. Whichever paint is used, a spatula (scrap card or spoon) will be helpful to transport it from its container to the painting surface. The bun tin type of palette could be used, placing a little of the colours required into the recesses and then dipping the fingers into the paint ready for painting. Use a sponge or cloth and clean water (white spirit when working with oil colours) to clean the skin and working surface at the end of a session.

The kind of mark that can be made varies according to the part of the hand used. Very thin lines and fine details can be achieved with a finger nail, especially when using liquid tempera colour. Charge the finger

nail by dipping it into a little liquid tempera colour that has been poured into a palette or other receptacle. The colour is applied by moving the nail across the picture ground, care will be needed not to allow the fleshy tip of the finger to touch the surface.

The palm of the hand, heel of the thumb, the forearm and the elbow can all be used for varying degrees of broader statements. The texture of the skin and hair on the back of hands and forearms can all be of use when allowed to remain impressed in the paint surface. Paint can be sponged, rolled or brushed onto the different parts of the hand or arm, or if the paint is rolled out onto a palette the appropriate part of the body can be placed into it to receive the desired amount of colour.

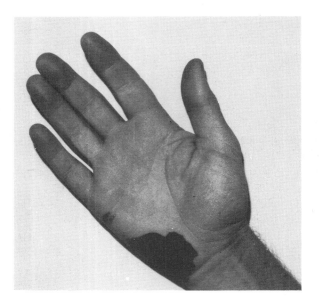

The fleshy part of the palm ready to apply effects of cloud in landscape

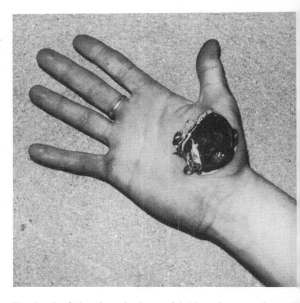

The heel of the thumb charged with colour ready to suggest a stormy sea

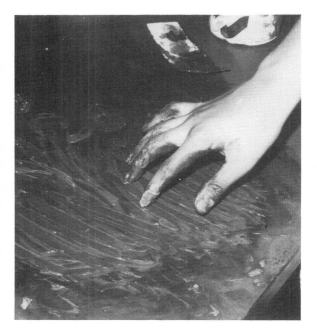

All the fingers of one hand used simultaneously. Dynamic and exciting marks have been made which were interpreted as grass and stems of flowers

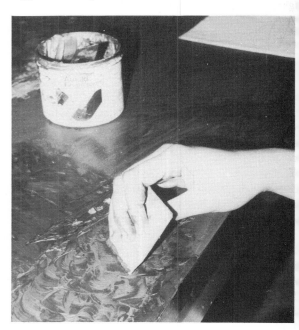

Card used as a means of developing textural qualities. Here the subject matter is water suggested by a turning action whilst moving the card through the paint

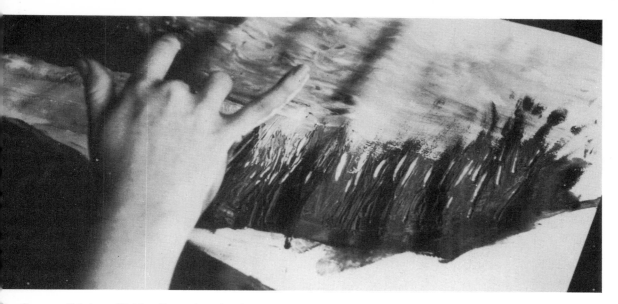

The finger nail is here flicking through wet paint to expose the white of the picture ground, to suggest light seen through grass. The sky had been painted previously, using the heel of the thumb. The cartridge paper has warped because it has not been stretched

Finger painting becomes more complicated as confidence is gained. It is frequently a result of trying out ideas, and having the courage to venture into the unknown. This sense of adventure and experiment will lead to a wider repertoire and the development of skills if it is associated with thought and discussion wherever possible, to establish what is of value in the painting especially to the artist.

At first, it is probable that one finger at a time will be used. With increasing confidence all the fingers, palms and other parts of the arms and body may be incorporated. This needs to be kept in reasonable control with due regard for the work in hand.

It is not advisable to use oil-based media with children for finger painting. Should it be used, it is important not to use oils that have a lead or toxic content. Oil colour can be removed with a little white spirit or turpentine substitute, then wash with soap and water. It is important that sufferers with skin allergies should check with their doctors whether they should take part in finger painting. It is also advisable to avoid any open wounds or sores. Finger painting is safe with common sense and due care.

A beginner would be well advised to use one colour at first. This will help to concentrate on the range of possible marks, whilst skills are being learnt. The colour range can be increased with experience and chosen to suit the painting in hand.

Experimenting with different ways of making marks in the paint will help develop an awareness of variety of textural possibilities. Try using the knuckles for either small closely-arranged marks or linear qualities by moving them across wet paint. Areas of colour could be wiped away by using a cloth. Interesting effects can be achieved by placing pieces of fabric onto the wet paint surface and then carefully lifting away to leave an impression of the texture of the fabric. Sponges, spatulas and knives could be tried to remove areas of wet paint. A residual film of translucent colour may be left behind and kept if desired. Different implements will give a variety of textures when pressed into the surface of the wet paint. The *sgraffito* process is incorporated by removing paint from the picture surface and the colour of the picture ground beneath is revealed.

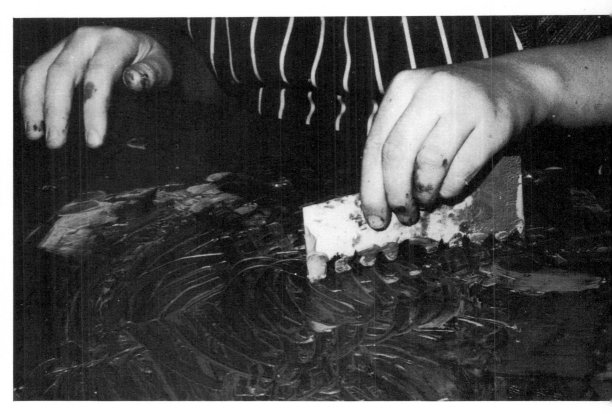

Using a comb cut from card

A traditional method is to use a comb, usually cut from card. Strawboard will serve well, or any piece of strong card, to make marks in the paint either combined with finger painting or alone. Put paint onto a sheet of card or paper with a spoon or a sponge, then move the card through it. Alternatively, dip the teeth of the comb into the paint in the palette and then move it across the paper or card to make a pattern or design. A set of combs could be made by cutting the teeth of each comb a different distance apart. The teeth could be shaped differently from one comb to another or within one comb. 'U' and 'V' shapes are possibilities to try. Any of the paint mixtures used for finger painting will work well.

The painting can be recorded by taking prints. Any kind of paper could be tried in experiments to see what kinds of texture and effects will result. Newsprint and cartridge papers will give satisfactory prints. Place the sheet of paper over the painting. Gentle hand pressure will be sufficient to take a print. It is worth keeping all prints made (further information on monoprinting techniques can be found by reference to the bibliography). Even the least successful finger paintings can be used in future work using other techniques. Torn or cut shapes from the prints are useful as collage material. The addition of inks to a wet painting or print can produce many interesting effects. A finger painting or print could be extended by pen and ink drawing and other painting or printing methods.

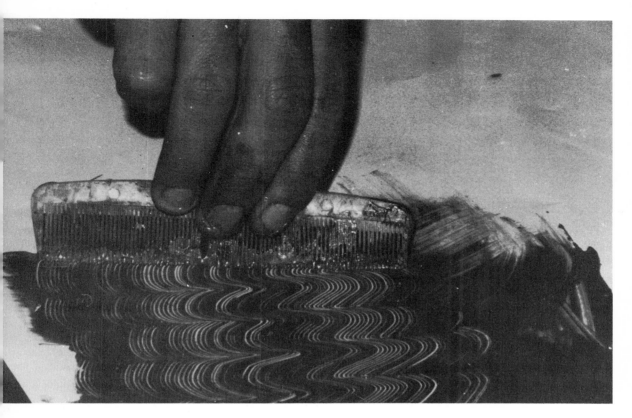

The finer teeth of a plastic comb leave precise marks in the paint

Ideas can develop quickly when finger painting. Pencil, pen and ink and the more usual drawing and painting techniques can be limiting to a child's need to give immediate expression to his experience and ideas. As well as being a technique for expressing sophisticated ideas by the most accomplished artists such as Klee, Dubuffet and Sydney Nolan, it can be used when making the initial roughs developing ideas for future paintings. Some of the values of finger painting to children have already been mentioned. It is an aid to the development of linear rhythms and as an extension of linear qualities in the use of combs. All manner of subjects lend themselves to this kind of treatment and in particular, plant studies, when the leaves and the stems offer exciting possibilities. Finger painting has a tactile relationship with clay modelling. There is a similarity in the statement of the essence of form by wiping away unnecessary areas. Both skills require the use of the fingers and hands.

Finger painting can help a child in the middle years of schooling move towards more advanced work without the frequently associated loss of spontaneity and individuality. The reason for such a loss may be due to the influence of the imagery to be seen in advertising. This often occurs side by side with dissatisfaction due to a lack of adequate technical skill in early adolescence. None of this need occur where teaching and guidance convey imagination and understanding. With experience, careful application and sensitivity to the possibilities, finger painting can be used to produce art work of the highest standards.

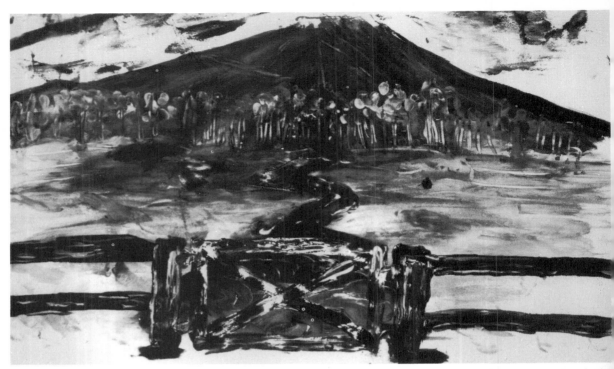

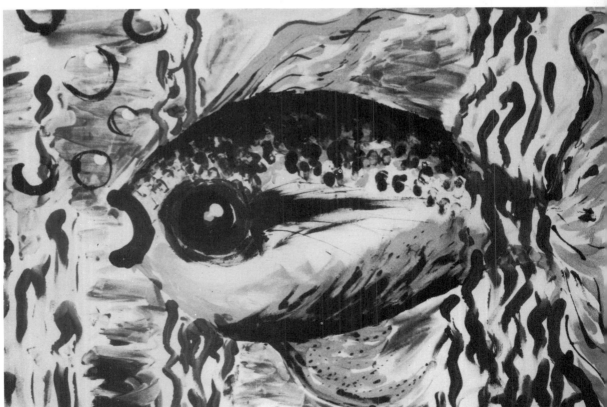

Finger painting can be useful for making a quick
study for a future painting. This landscape was later
used as the basis for a painting combining finger
painting with the use of spatulas

An early finger painting by Harvinder Soor. Painted
in a very short time, it expresses his experience of
living in Kenya with its rich greens and vivid browns
and reds

Caroline Hicks has used three methods in this painting
of an imaginary fish. Finger nails were used for fine
linear marks; finger tips for wider marks and textures
on the fish's back; the broadest marks were made
with the heel of the thumb

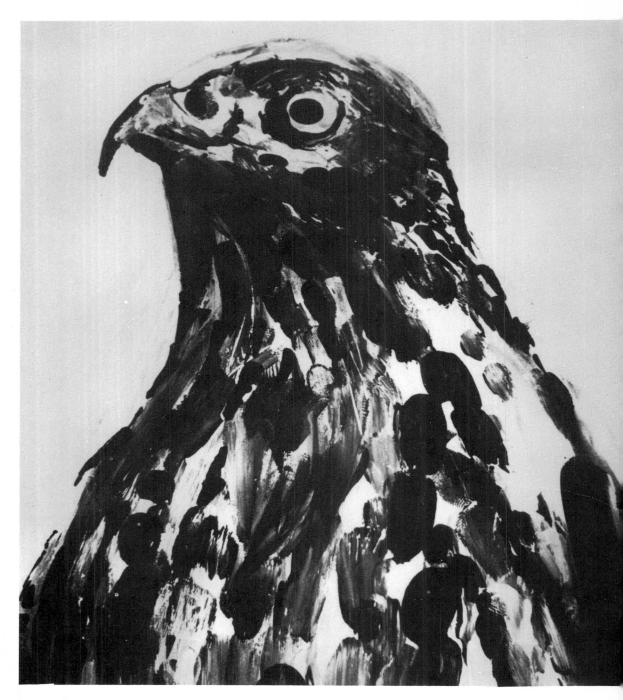

Detail of a hawk. The author used liquid tempera
colour on white card. The texture of the feathers
on the breast were stated using the ball of the index
finger. Where smaller, the tip of the finger was used.
The background, in white and subtle tones of colour
used for the feathers, was painted with the heel of
the hand. Fine details were painted with a finger nail

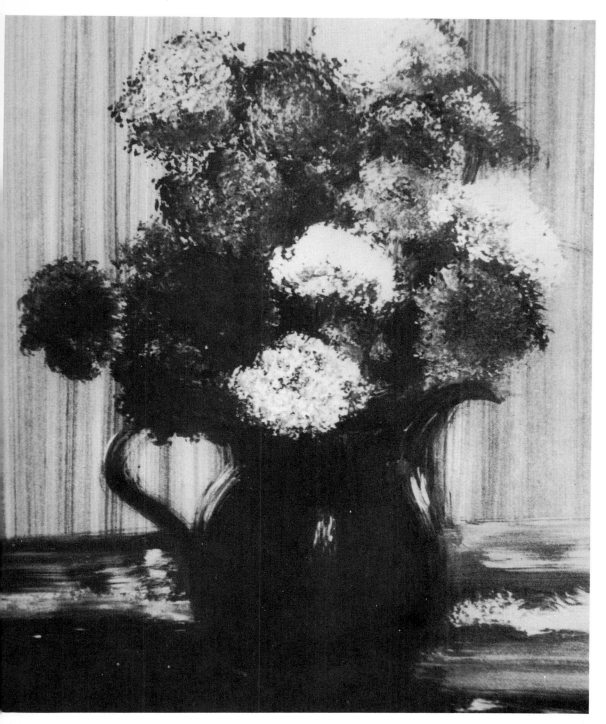

Chrysanthemums Using sponges, the opaque quality of gouache has been used here in the final statements painted over liquid tempera colour. Only light presure was used with a wiping action of rag to apply colour for the curtained background

SPONGE AND RAG PAINTING

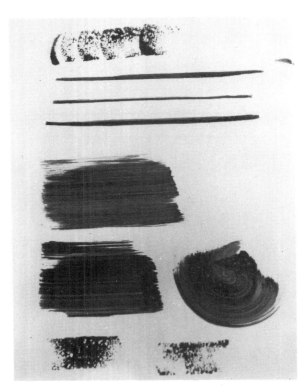

Examples of marks made with a sponge. The marks at the top and bottom of this illustration have been made with a sponge loaded with powder colour and pressed lightly onto a sheet of sugar paper. The broad marks in the centre are the result of a wiping action. The three linear marks were made with the edge cut from a synthetic sponge.

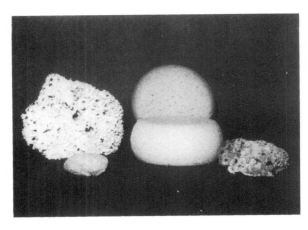

In the centre are two synthetic sponges. On either side are natural sponges, easily identified by their irregular outlines and the wider variety of pore size. The smallest is an artist's quality sponge, useful for work with water-colours, especially to remove colour to suggest highlights

Sponge

Sponges are commonly used in the studio for cleaning, creative printmaking and ceramics; rarely have they been used for painting. Leonardo is reputed to have applied a sponge laden with colour to a painting surface as a starting point for imaginative work (*Speculative Invention of Accidental Blots and Stains*, Leonardo da Vinci). In recent times sponges have been used by artists in combination with other techniques. Rarely have they been used alone to produce a painting. Yet it is possible to complete exciting and worthwhile work with a wide range of colour using only a sponge applicator.

One important advantage of painting with a sponge is the speed with which work can be completed. This can be particularly valuable in the school art lesson, enabling work to be started and finished in the one session. When paint is applied directly, without reworking, the finished appearance is of spontaneity and a fresh surface quality. The excitement and enthusiasm with which young people approach their work can be expressed and not frustrated as is sometimes the case with more demanding techniques. With experience, spontaneity can be combined with sensitive and subtle colour and texture. Enthusiasm can be caught up with exciting work whilst learning control of, and expression with, the media.

Large areas can be painted, with little concern for detail, in a short space of time. Atmospheric and textural qualities can be established as grounds on and from which imagery can be developed. There are three main ways this can be achieved:
1 Moving the hand-held sponge loaded with paint across the picture surface;
2 Pressing the sponge directly onto the picture ground — repeats of this action will produce interesting textures, pattern qualities and illusions of forms;
3 A wiping action to remove areas of paint already applied. This is best done while the

paint is still wet. Certain areas could have paint completely removed from them or thinner layers could be allowed to remain. These principle actions can be varied by different arm and wrist movements such as twisting, circular and zigzag. With practice a repertoire can be developed; experimentation is important, as a precaution against work becoming facile and repetitive.

Precise detail is difficult to achieve with a sponge if working up to a line. Where the sponge is used to make an area of colour or a mark producing its own sense of line the statement of detail becomes much more possible. Suggested techniques are given below.

There are two types of sponge, natural and synthetic. Natural sponges are expensive but much more versatile and yielding to an artists needs. Should it prove difficult to get natural sponges of an appreciable size from artists' suppliers (they are often dense with small pores close together), they can be purchased from a pharmacist or supplier of domestic goods. There are two main limitations to the use of natural sponges as paint applicators. They are uneven in shape and difficult to cut to a precise shape. The smaller pieces are good for details and linear qualities. If an edge is pinched between thumb and forefinger a fine mark (or line) can be made.

Whatever the size of the sponge interesting textural qualities can be achieved by pressing it, loaded with colour, onto the picture surface. Different amounts of colour used and pressure exerted will give variations in the textures achieved.

If the following suggestions are observed the sponges will last well and give good value:
1 They should be washed thoroughly from time to time. At the end of each working session they should be rinsed in clean water as thoroughly as time will allow;

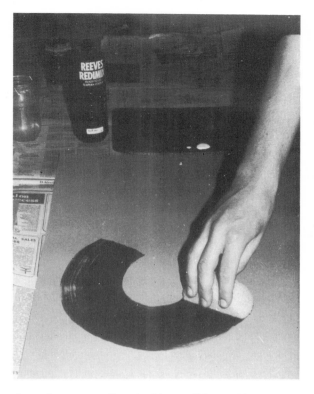

A good measure of control is possible working with a moist sponge. The painted area here has clearly-defined outlines and the width of the sponge decides the extremities of the shape made

2 When washed, gently squeeze (never wring) them out and hang up or place to dry where air can penetrate the fibres. Do not store them enclosed in a bag or confined space;
3 It is not advisable to boil them since it causes the fibres to harden and to deteriorate;
4 Natural sponges deteriorate quickly if used with strong alkaline solutions such as certain cleaning agents and disinfectant. They will become slimy if soap is rubbed onto them.

Use the largest sponge for the largest areas of a painting. The quickest method of application is a wiping action across the surface. The less pressure used, the more 'streaky' the effect will be, since the paint will tend to be deposited by the sponge projections. With more pressure more paint is squeezed out and

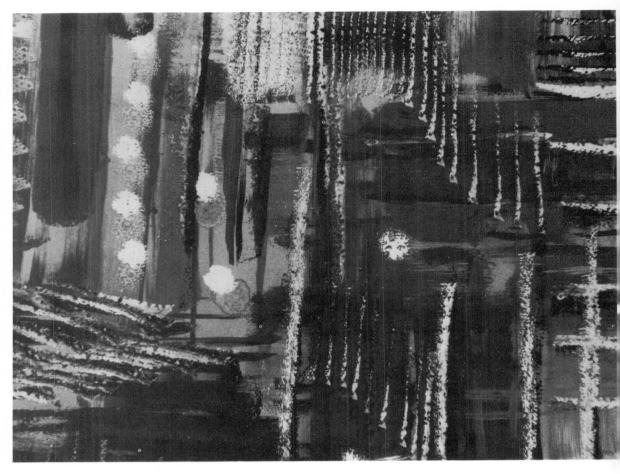

An abstract based mainly on vertical and horizontal
marks made with a synthetic sponge using liquid
tempera colour on sugar paper

a better coverage is obtained. A rest during a
journey across the surface may lead to a build
up of paint and an uneven coverage if pressure
is maintained at the stopping place.

Synthetic sponges usually have an even
pore size throughout and are therefore use-
ful when wanting to cover large areas with
an even, flat coat of paint. There are two
main pore densities — coarse and fine (with
little variation in between). They are sold
by most domestic suppliers; and they either
fill the hand or are larger. It is difficult to
find one as small as the smallest 'artist's
sponge' but detail can be attempted by
using corners and edges or by cutting small
pieces. Whatever the form of the sponge,

it can be cut with scissors to provide any
desired cross section shape or edge. Angles
and straights of many features of the envir-
onment, such as buildings, scaffolding, rail-
way lines, bridges and street furniture are
best painted with the straight edges and
corners of a sponge. Whereas the bluff edges
of rounded sponges lend themselves to
painting undulating landscapes, foliage,
animals, clouds and sea.

When painting with a sponge using water-
based media it is advisable to give one applica-
tion of colour. Overpainting, with any degree
of pressure, tends to cause previous paint to
be lifted by the sponge. Certainly this will
occur after two or three coats have been

applied. This is particularly so if a slow wiping action is used. Most problems of this kind happen where water-based colours have dried before the next application is made. Painting into colour that is wet is possible especially if light pressure is used. It can be particularly helpful when painting impressions of foliage, flowers and clothing. Care should be taken with paint that may become 'muddy' when working wet into wet.

There are many different shapes and sizes of sponge to try. Individual preferences after experimenting will help to decide which to use. General guiding principles should be kept in mind.

Working with a sponge that is moist will give a greater sense of control and the probability of a higher success rate. Squeeze out excess water, dip the sponge into the paint and apply it to the picture surface. Dampness helps to control the transfer of paint. It is also important when removing excess or unwanted colour when, by using a blotting action the dampness aids the absorption of the paint into the body of the sponge. This can be a positive painting method when the action is accompanied by twisting and wiping movements to produce effects of cloud, sea, flesh, lighter tones and highlights.

One of the main reasons for painting with a sponge is to answer the needs for particular textural qualities. Textural variations are virtually endless. Try experimenting with different amounts of moisture when applying colour before working on a painting. The different pore density of the sponges available will provide a variety of textures. There is usually a wider choice of natural sponges obtainable. Synthetic sponges tend to be either coarse or fine. The pore density will influence the kind of mark made and it is more pronounced the lighter the pressure used while applying the paint to the picture surface. The more pressure used, the less distinctive will be the character of the sponge (this will also be influenced by the amount of paint on the sponge).

As well as being a paint applicator, a sponge can be a useful aid otherwise. When stretching paper in preparation for a water-colour, a clean sponge is an efficient means to wipe away excess water after the paper has been soaked and before fixing it to a drawing board with brown gummed paper strip. The absorbent nature of a sponge makes it valuable for blotting a wash of water colour. This not only gives a means of stating textural qualities, as previously noted, but also speeds up the drying rate.

The texture and the quality of the painting surface will play significantly in the end result. Highly textured papers usually lead to paint being readily held by the raised areas and less so by the recesses. The darker pockets (recesses in shadow) can effect the colour perception. For instance, an application of yellow will appear darker and suggest green rather than yellow. Smooth, soft paper will absorb more colour (than smooth, hard-surfaced) which usually leads to increased transparency. Building layers of colour on top of each other is usually more successful on hard-surfaced papers or card.

Rigid working surfaces allow pressure and sweeping movements which are part of a sponge painting technique. Fix paper or card with drawing pins or adhesive tape onto a drawing board which is either resting on a table or held firmly on an easel.

Ready-mixed liquid and powder tempera colours are particularly suitable for painting with sponges. A tray or palette will be needed for mixing colours. Powder colours allow a wide variety of consistency. Liquid tempera, being ready for use, will facilitate spontaneity. Children will enjoy using it but a danger is a tendency to do so straight from the container without mixing colours to encourage an individual colour sense. With guidance the danger can be obviated. Powder colours need mixing with water. The less water used the more the granules of powder will be seen and can be effective in a richer textural statement.

Much fine work has also resulted from sponge painting with water-colours from tubes or in block/tablet form, gouache and in oils. It is difficult to control colour consistency when using paint squeezed from a

tube, so roll the paint out to the desired consistency on a tile. Water-based printing inks could be used as an alternative. The paint or ink can be thinned if necessary (mix the colour and water to an even consistency using a palette knife before rolling out) or thickened using one of the following methods:

1 If the colour from the tube is too 'runny' or too thin, excess moisture can be removed by laying over it a sheet of newspaper or blotting paper;

2 Moisture will evaporate if left in the atmosphere but this may take up valuable working time.

It is as well to check equipment before use to allow time for necessary adjustments to be made. This is particularly important for successful working with a class of children and essential for demonstrations of known techniques. Artists' water-colours are expensive and if used in school are more appropriate to painting with good quality sable hair brushes by senior pupils. Tempera colours from the tube are more appropriate. Their fast drying rate relates well to the speed of working facilitated by sponges. Acrylics could be tried, with due regard for washing sponges to prevent paint drying in them; again the cost involved may rule them out for general use in school.

Colour in block or tablet form has a place when painting with sponges which are not so easily worn as the fine hair of water-colour brushes. It is still difficult to get good colour brilliance without working water into the surface, but once the surface of the colour block has been moistened it becomes a clean and efficient means of colour application with a sponge. There are reservations, colour mixing is difficult if not impossible; the range of colour consistency is narrow; and it is difficult to charge the sponge fully with paint.

The opaque nature of gouache lends itself to statements of detail where this entails second or third applications of colour over areas that have been painted with broad sweeps of the sponge. Try this method when painting foliage in the foregrounds of land-

The texture of a natural sponge has been exploited here with the sponge loaded with liquid tempera colour repeatedly pressed over paint that has been wiped across the surface

scapes; flower studies; clothing; skin and feathers; and textural statements in abstract paintings. Nevertheless in school this role is best played by poster paints or tempera colour. Gouache has many exciting potentials to offer the young artist but it is expensive. It could well be applied with a brush in combination with other types of paint and methods of application. John Piper has often used gouache in his work. See the series of paintings he did between 1967 and 1968, for instance *Lonzac, Charente* 1967. Try applying gouache colour with a sponge, light over dark. The opaque light colours hold well over a darker under painting.

Sponges and rags produce soft, mellow qualities when working with oils. They can be used to apply paint to the picture surface

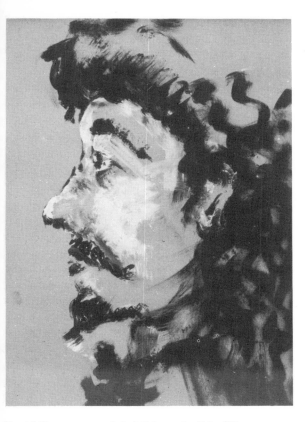

David Tavarre completed this portrait in fifteen minutes. It is a dramatic and exciting image with the white highlights almost overstated. The lively marks are mainly due to the speed of execution, facilitated by using a sponge

refined of statements. This becomes even more difficult when painting with rags. Children and adults can get a sense of achievement working with only a sponge as an applicator, but it will have more use when used in combination with other methods of application. Both approaches should be tried and individuals allowed to experiment and to develop their work as far as possible. The full potential of sponges for painting has not yet been established. At one moment they may lend themselves to printmaking techniques and at the next to painterly qualities with a minimum of fuss and equipment, yet also able to work for the artist concerned with the most sophisticated of subject matter.

Children will enjoy experimenting, as almost certainly Leonardo did, with all kinds of approaches to painting. The symbolic interpretations they may make from a sponge print or from a sponge loaded with paint being dropped onto a sheet of paper or thrown at a sheet of hardboard can be exciting and worthwhile. This is a form of *Tachisme* (French for blot or stain) and is very similar to Action Painting. The suggested imagery can be developed with sponges and/ or brushes, pens, knives, rollers or whatever seems appropriate.

Rag

Although much of what has been said for sponge painting applies when working with rags, it is necessary to point to significant characteristics. The wide range of fabrics available gives much more scope for textural variations from the finest and delicate marks possible with offcuts of nylon, rayon and silk to the coarse, broader statements from the thicker hessian. In between are many possibilities offered by natural fibres such as wool and cotton; man-made fibres for example polyester and *Dacron;* and various combinations of both. Experimentation will be important to decide which are preferred for particular work in hand.

Certain observations from experience may prove helpful. It is vital to test the different

or to work into the colour while it is still wet so that it becomes much more a part of the primed canvas or board. The grained surface of the canvas has its own virtues but obtrudes upon the softer textures which can be obtained when working on a board. It is possible to work over oil colour that has dried. The sponge can be used to enhance the texture of the dried paint by working more colour into it. Try painting with a sponge that has been dampened with a little pure turpentine. A dry sponge or rag tends to remove wet oil colour when moving the sponge across the picture surface.

The paintings illustrated in this section are examples of work completed entirely with sponges. It is possible to achieve a sense of detail without being able to make the most

Liquid tempera colour was used for this painting
which contains richness of colour and texture achieved
using most of the methods for applying paint with a
rag described in this section. The antennae, legs and
veins in the wings were stated with the rag pulled
over a finger nail pressed tight against it. Corners of
folded rag helped with other details such as the eye,
marks on the wings and the flowerhead. The texture
of the wings was created by repeatedly pressing
lightly with a screwed up rag loaded with colour

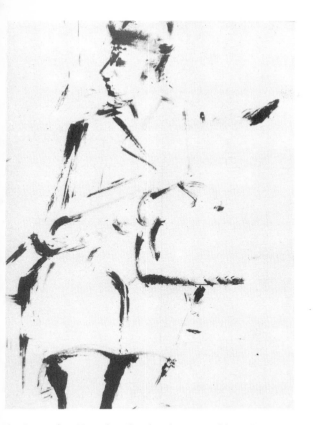

A piece of cotton sheeting has been used here to draw with powder colour the main plan for a painting on white card

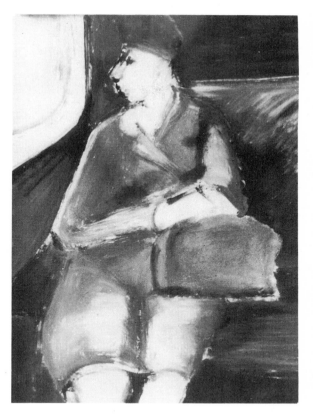

The next stage has been completed. The main, broad areas of tone and colour have been painted. There remain the final details of face, hands and colour subtleties

fabrics with the colours available. Experiments to make:
1 The versatility of a fabric — can it be folded, creased or screwed into a ball?
2 The kind of marks that can be made relating to its texture;
3 The absorbency and the ability of a fabric to preserve its character when loaded with colour.
Generally, get to know how to use a fabric to best advantage as a paint applicator.

Broad areas of colour are usually best stated with a fabric of medium weight and thickness. Corduroy, felt and cotton denim are all useful for this. Most fabrics can be used for large areas by making balls or pads of them. These are then dipped into the paint — liquid tempera colour is suitable — for application to the picture ground.

Cotton is a good all-round paint applicator. A piece of discarded cotton sheeting can be used for large areas; drawing with paint; all the main subject groupings; and is most suitable for details.

Rags are difficult to use when stating fine points and linear characteristics. The finest details are often more difficult to accomplish than with the corners and straight edges of a sponge. There are always ways around this problem, for example:
(i) Screw up the rag to leave pointed/jagged protuberances. These can then be dipped into the paint before painting small details. The stiffer the fabric the more control can be exercised.
(ii) Fold the rag (much the same as when folding a pocket handkerchief). The corners and straight edges will produce clear and

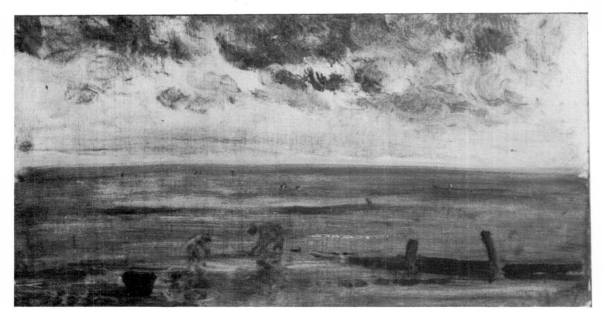

The Cocklers. This seascape of tiny bent figures
following the tide out, collecting cockles in baskets
and buckets, was painted with a piece of cotton
denim, using oil colours on hardboard. Paint was
applied, then wiped away before applying marks
for clouds, figures and foreground

definite marks of detail.

(iii) Wrap the rag round a finger, load with
colour and use the finger nail pushed tight
against the fabric to state fine linear qualities
(similar to finger painting).

There are four main uses of rags for the
painter:

1 Cleaning equipment and work surfaces;
2 As a paint applicator. In addition to the
possibilities already noted try making marks
with a pad. An individual impression will be
related to printmaking. Interesting textures
can be developed by overlapping the marks
made. Try varying the amount of pressure
given when applying the paint to a surface;
3 Wiping away areas of wet paint. This has
often been valuable in printmaking particu-
larly as a subtractive process in monoprinting.
In painting, the pleasure of colour subtleties
obtained from wiping away areas of wet
paint is best achieved with a rag. It can be
tried with a water-based medium on paper
but the fast drying rate often defeats it.
With oil colours it is worthwhile and can

lead to satisfying textures, moods, atmos-
pheres as well as subtle and harmonious
integrations of colours. Care will be needed
if working on canvas or paper. Too much
pressure will cause stretchers at the back to
press against the canvas leaving a 'margin'
line round the painting. Wiping away paint
with rag may disturb the surface of paper and
cause it to break up. Choose a hard-surfaced
cartridge paper or a sheet of card. From
experience, the most suitable surface for this
technique is primed hardboard, especially
when working with oils;
4 As a textural contribution to a paint
surface. This should properly be related to
collage. In the work of such artists as Michael
Fussell and Antonio Tapies the materials
used become an integrated part of the picture
surface. Fussell[1] has used tissues soaked in
emulsion paint to create interesting tonal
and textural statements. These have usually
taken up twisting, swirling movements in low

[1] Studio International, March 1964; and John
Russell in 'Private View', pp 288-9, Nelson 1965

Detail showing clearly the application of paint after previous layers have been partially removed. Contrasts of texture and tone are achieved as well as softer, more gentle suggestions of subleties of colour and movement

relief; the twists and wrinkles of the tissues become an important part of the overall effect. His painting *Kleenex*, which can be seen in the Tate Gallery, London, is an example of his concern for light and its play on surfaces. He has emphasised the effect of light by using mainly white paint (occasionally he introduced areas of pure colour). Reference to the work of Antonio Tapies and Ablerto Burri will be worthwhile, Tapies[2]

[2] *Tapies 1954-1964*, Alexandre Cirici, Methuen 1965 and *Antonio Tapies*, Michel Tapies, Barcelona 1959

for his combinations of materials including fabrics and Burri for his use of hessian in works such as *Sacco 4*, 1954, in the collection of Anthony Denney, London. Emulsion and gloss paint will have their own powers of adhesion to hold lightweight fabrics to a picture surface — preferably board or card. Whereas emulsion paint could be used in school, it is more likely that tempera colours will be available. Mixed with a little pva binder, powder or liquid tempera colour will serve well to hold rags to a picture surface.

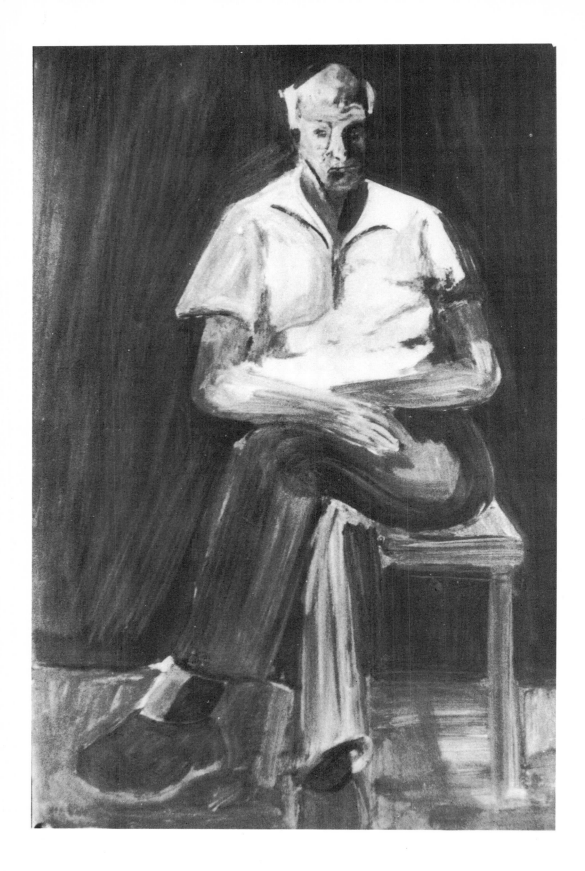

For general purposes in the classroom, painting with rags is most sensibly attempted with water-based media. Should it be desirable to retard the drying rate, try mixing paint with *Polycell*. The main argument against this, the reduction of colour brilliance, need not be inhibitive if small quantities of *Polycell* are used (one part *Polycell* to six parts colour).

When working with sponges and rags a mixing palette will be necessary. Colour can be mixed with a palette knife on a formica offcut or any non-porous surface (see 'Technical Notes'). To moisten a rag a little, have a water container with a neck wider than the usual jam jar. A small plastic bowl or dish will serve well. Before starting work have a supply of suitably sized pieces of rag ready cut or torn for use.

Painting with a sponge or rag will inevitably require a certain amount of pressure so that a firm and stable working surface will be necessary. The smooth surface of a sturdy table will serve or, if using an easel, the paper or card can be pinned, taped or clipped to a drawing board. Remember the word of caution when exerting pressure on a stretched canvas. Ideally a piece of hardboard could be used as a painting surface. It may still be necessary to steady the work or the easel with the non-painting hand when stronger pressure is being exerted for instance when wiping wet paint away or when working paint into the primed board. With the work in a horizontal position, a formica-topped table provides a smooth steady surface to support paper or card and is easy to clean at the end of a working session. Clearing up will be a simple operation, whatever the working surface, if it is protected by old newspapers.

It is possible to complete a painting entirely using rags as applicators. Those paintings in oils are considered to be the most satisfactory especially when they have been carried out on primed hardboard. Much exciting and worthwhile work has been achieved with water-based media in the classroom. Children will enjoy exploring the possibilities of working with rags. The work they do may well extend into areas of textural exploration using a variety of media such as shoe polish and waxes, dyes and inks applied and worked into surfaces.

The early stages of painting with rags most often require a firm surface to allow pressure to be exerted. Strong pressure and movement has been used in establishing broad statements of colour in this unfinished painting on card which was placed on a steady table top

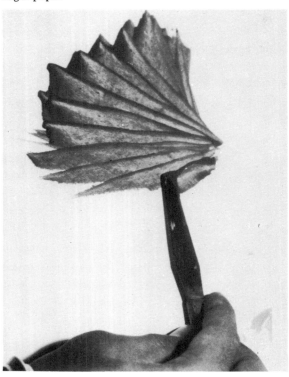

Spreading paint with the blade held at an angle to the painting surface. Liquid tempera colour on sugar paper

A translucent quality can be achieved spreading paint with more pressure. Here liquid tempera colour is being applied to cartridge paper using a plastic painting knife. Pattern and texture can be explored in this way. In this illustration only the end of the knife is touching the paper

PAINTING WITH KNIVES

The painting knife will perform certain effects that are very difficult to achieve with a brush. It is much easier to produce a very fine line with a painting knife. This is advantageous when wanting to state linear subjects such as string, ropes-sailing rigging, edges particularly of leaves and petals, wire, twigs and hair. The knife enables purity of colour to be preserved even in the thicker areas of paint, a much more difficult task with a brush. Working with a knife allows a direct, spontaneous approach often not achieved with the largest paint brush. Interesting textural qualities can be achieved using the *sgraffito* process; and using the knife for scumbling. Up to the present time the painting knife is most commonly used as an addition to the brush rather than as a replacement for it.

Painting with a knife is a direct method of working which removes some of the many fussier details of the process when working with a brush. *Impasto* painting, typical of the painting knife technique, is attractive and often rich in colour. But it tends to be superficial and loses its interest after a while. Before trying to paint with a knife alone, a beginner might well be advised to use a combination of brush and knife. When skill, experience and confidence are acquired, attempts can be made to paint with the knife alone. Paintings completed entirely with the knife have a tendency to be hard-edged and slick in appearance unless the knife has been used with care and dexterity (the facility to use the knife well will come with practice). The knife allows for a greater freedom in handling paint for a wide variety of marks and statements.

Paint can be spread with the flat of the blade or with its edge. A thin layer can be given if required by pressing harder with the knife. A translucent quality of colour can be achieved in this way even if working with oil colours. The effect of translucency is more likely to be possible when working on a white ground. Nevertheless painting with a

knife lends itself to the use of thicker paint.

The blade of a painting knife is usually thinner than that of a palette knife. It tends to become sharp with use. Care is needed to avoid piercing the picture ground (especially paper, card, and canvas) with the edges or the point of the blade. Other important differences from the palette knife are increased flexibility which allows greater control when applying colour; and the shape. The heel of the painting knife is bent. A palette knife is commonly associated with mixing colours on the palette or with cleaning a palette after a working session. It can be used for painting but does not readily lend itself to statement of fine detail or subtlety and control when applying colour to the picture ground.

Paintings of merit have been completed entirely with painting knives. Some of these have been by amateurs and others by artists of repute such as Kyffin Williams, *Cottages at Llanddona* (Steel Company, Wales); Peter Coker — his series of paintings *Forest* (one of the series is in the Herbert Art Gallery, Coventry), Nicholas de Stael — *Study at La Ciotat*, 1952, (Tate Gallery, London); and William Scott — *Ochre Painting*, 1958 (Tate Gallery, London).

The best painting knives are those made from one piece of forged steel, straight or trowel shaped, usually set in a wooden handle. Avoid those that are welded. They have a tendency to break at the join which is usually made at the heel of the blade. Some manufacturers of artists' materials are putting on the market cheaper plastic knives. The straight blade might be said to be an extension of the painters arm and a more direct way of applying paint.

A trowel-shaped blade requires more control and is capable of a wider range of marks and affords fine subtlety of colour.

It is possible to complete a painting with one knife but it is advisable to have a basic set of three. A larger, longer and straight blade is useful for making sweeping strokes for the largest areas of a painting and for under-painting (such a knife could also be used for cleaning the mixing palette). A

Underpaint applied with the least flexible straight blade. It is possible to give a reasonably even coat of paint with the knife without achieving the quality of wash possible with a brush (badger mop) and water colours

smaller blade — 10 cm in length (approximately) — would be necessary for colour mixing. Details will require a slimmer blade to suggest, for example, the masts of ships, windows and roof tiles of small buildings, street furniture and figures in a landscape. The triangular or trowel shaped blades are the most suitable for suggesting textural qualities of clothing, rock structures, scaffolding and walls.

Underpainting and the first layers of paint should be applied with the least flexible of the straight blades. Pressure is needed to force undiluted paint into the pores of a canvas or other rough surface. Working on paper or card this is not so necessary but the straight stiffer blade is still the most suitable for the application of broader areas of colour. The larger the painting the larger the knife to be used for underpainting, up to the largest which is most commonly 20 cm in length. Useful for medium sized paintings is a blade of 10 cm in length.

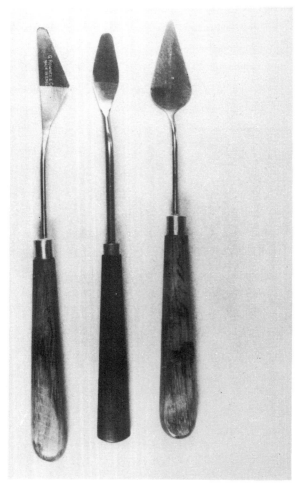

Three painting knives showing something of the variety of blade shapes available. These three are all most likely to be used for detail work

The straight and more rigid blade with three trowel shaped blades. The blade on the right and the straight blade could be included in a basic set of three

The painting knife should have a blade that tapers. It will be needed for different kinds of marks in the painting. The degree of flexibility in the blade is important. It is not possible to spread the paint accurately with a blade that is too flexible and weak. On the other hand a blade that is too stiff requires more pressure to apply the paint which will then ooze out from underneath the knife and not remain where intended.

Details can best be stated either using a pointed, trowel-shaped blade of 5.5 — 7 cm long or a stiff pointed blade (such as a pen-knife). The first is good for working into wet paint; and it is useful for working over thicker layers of underpainting. The second is helpful when dealing with small areas and marks especially when using the edge of the blade for lines and the tip or point for small marks such as facial details in portraiture.

A good general purpose knife is one of 12.5 — 15 cm long, with a straight flexible blade. It is useful for mixing colours on the palette, blending colours whilst they are still wet on the picture surface and for smoothing out unwanted textures.

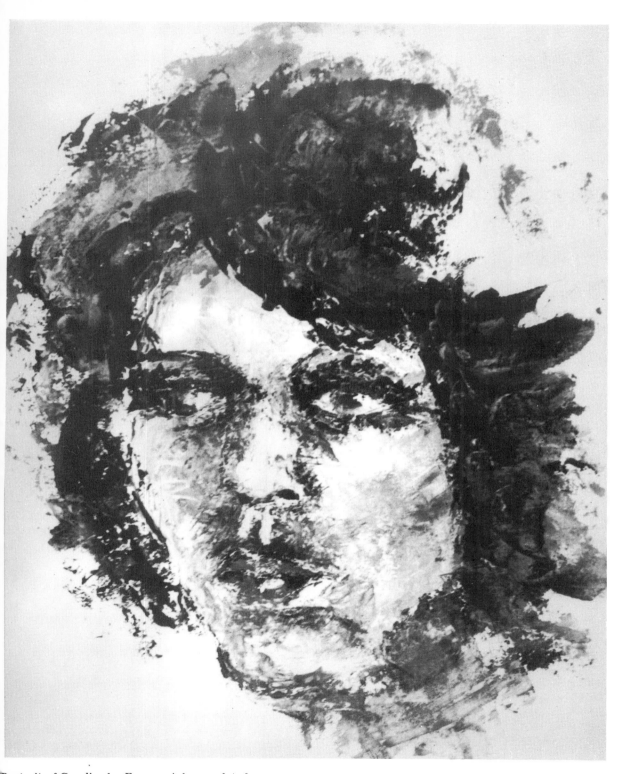

Portrait of Caroline by Frances Ash completed
using only two knives with liquid tempera colour on
cartridge paper

45

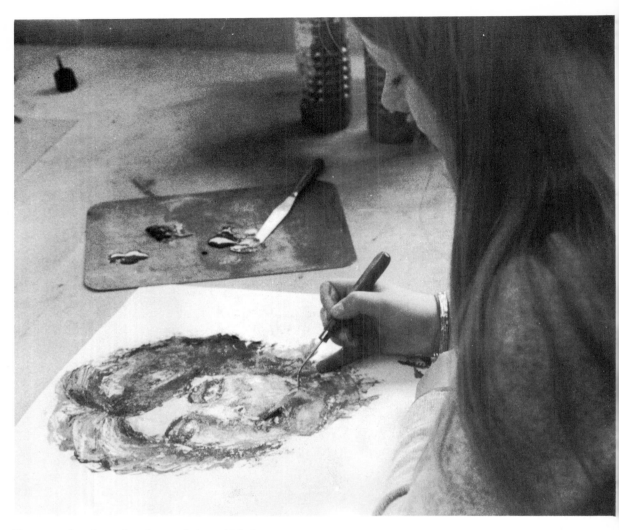

Frances using the pointed trowel shaped blade to
state details of the mouth. A straight blade is used
for mixing colour here on a metal palette

Where more linear details are required a penknife or less flexible, straight painting knife can be used as in this portrait

Personal preference after practice will help to determine which knives to use. The smaller trowel-shaped, flexibile blades are often rejected by artists as paint applicators because they are thought to be too thin and difficult to control the paint with. Nevertheless they can be useful and the least flexible of them can be a good choice for stating certain areas of detail in for example flower studies, landscapes, hair and clothing in portraiture, as well as providing interesting textural qualities. They have been used successfully for mixing pigment with an oil vehicle and for mixing colour with additives such as french chalk.

It is important that knives should be kept clean. Paint that has been allowed to dry on a blade will injure the paint film when the knife is used. This may result in an uneven layer of colour and cause unnecessary frustrations. Keep a rag near to hand to clean a blade immediately after use.

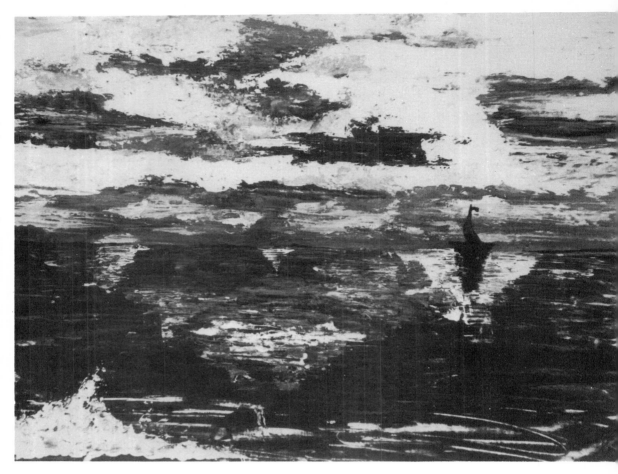

In this seascape by Debbie Wetherfield, poster colour
has been applied impasto. Interesting textures and
effects of water can be painted in this way. In the
foreground the *sgraffito* technique has been used.

There is a wide variety of textural qualities
that can be achieved with a painting knife. If
the knife is scraped over the surface of a
painting, especially one on a grained ground
such as canvas, the white grain will be
exposed and seen against the darker colour
which is held in the pores or recesses. A
painting knife can be used for scraping away
areas of paint to leave qualities of colour
and texture which can be incorporated as a
positive part of a composition. This may be
an intentional part of a process or a happy
accident. The *sgraffito* technique is concerned
with scraping away areas of wet or dry paint
to reveal layers of colour previously applied
or the colour of the picture ground. Certain
effects such as white lines or highlights can
be successfully achieved in this manner. A
useful alternative to the painting knife for
sgraffito work is the stiff sharp pointed
blade of a penknife. With the more flexible
blades of some painting knives, control can be
maintained by holding the knives low down
near to the blades. *Sgraffito* is valuable for
stating interesting textural qualities and
contrasts of tone and colour.

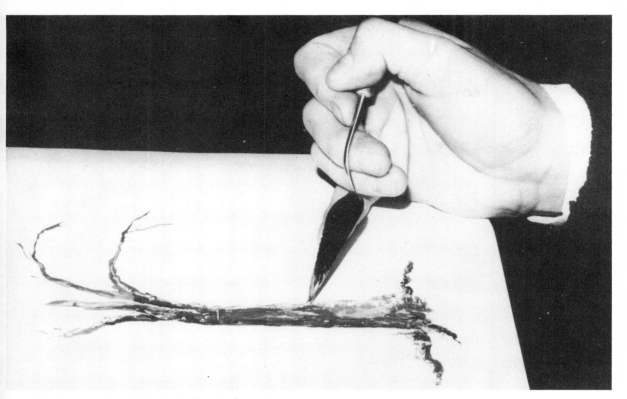

A pointed trowel shaped blade used to apply poster colour *impasto* to state highlights on the bark in this tree study

Scumbling can be good for stating impressions of foliage, clouds, certain effects of water as well as being a useful way of painting highlights such as those often to be seen on foreheads, noses, knuckles of the hand and crests of waves. 'Load' the knife with colour and take it lightly across the surface allowing the texture of the paper, board, canvas or the texture of paint previously applied to catch the colour. If this process is being used for highlights it will involve painting light over darker tones.

The opaque nature of oil colours and, to a lesser degree, of poster paints make them most suitable for the application of paint *impasto*.

It is advisable to have a logical system of working. The development of a painting may vary from artist to artist. Some prefer to work from light to dark tone. Other painters may prefer to begin with the darkest

tones when it is advisable to apply a coat of thin darker colour first, using the knife edge across the picture ground. It is then easier to apply lighter tones of thicker paint, *impasto* if preferred, making the final statement with the lightest colours. The knife should be used confidently pressing it firmly onto the paper, board or canvas, except when variations of pressure are needed for particular textures.

Tonal values are important whatever the method of application being used. This is particularly so when working with a painting knife because colour purity and intensity are much more in evidence. It is therefore equally important that the subject matter for a painting is understood before beginning to paint. If not, much paint will be wasted, leading to annoyance which is not usually conducive to the satisfactory completion of work.

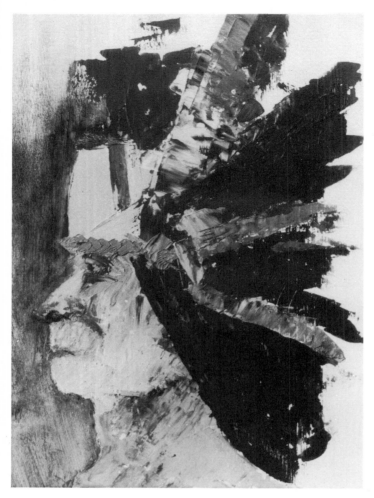

Experiments with oil colour and a straight blade on white primed hardboard lead to this Indian Chief. The feathers of the headdress are the result of applying paint with the edge of the straight blade. Often beautiful and exciting colour mixtures and textures can be created with a knife. The softer quality to the left of the face was applied with a rag

When working with a knife there is a tendency to force colour into the pores of the picture ground by applying paint with the blade flat against the surface. This can be avoided if the blade is held at an angle with one edge touching whilst being moved across the paper, board or canvas. The paint stays on the surface and its freshness and colour intensity is maintained.

Painting with a knife lends itself to dramatic subjects and to strong contrasts of light and dark or to the use of complementary colours in juxtaposition. To achieve relative values of light and dark the painting knife must be used in a direct and confident manner moving it firmly across the picture ground. A canvas surface will withstand a certain degree of pressure but a canvas board or primed hardboard are ideal for the dramatic treatment of subject matter.

Much can be achieved with a painting knife working spontaneously with only a

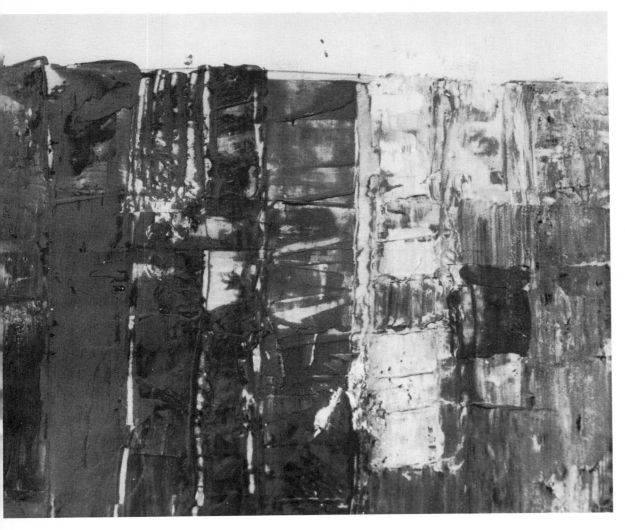

Here poster colour has been applied to white card with a trowel shaped blade. Experiments applying blues over reds and white and lighter colours over dark lead to this abstract painting

minimum of compositional preparation. Personal expression is important and can be attempted with an increasing measure of satisfaction as experience is gained with the knife. Exciting abstract work has been done in this way, as well as subjective responses and interpretations from the first marks made with a knife.

Oil colour and the faster-drying water-based media poster colour and liquid (ready mixed) tempera colours used separately, can be mixed on the picture ground by pressing the knife loaded with colour into the first colour application, 'wet into wet'. The slower the drying rate the more suitable the media for this purpose. It is difficult to control colour using this method within a particular area and whereas it may well be possible to produce successful abstractions and abstracts, it is difficult to exercise the control often required for representational interpretations of a subject.

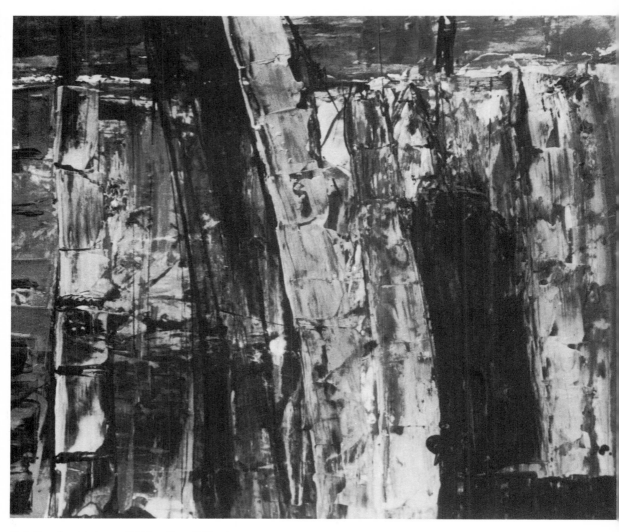

Painting 'wet-into-wet' it is often difficult to control
colour. Experiments with the technique have been
used in this abstraction based on sailing rigging

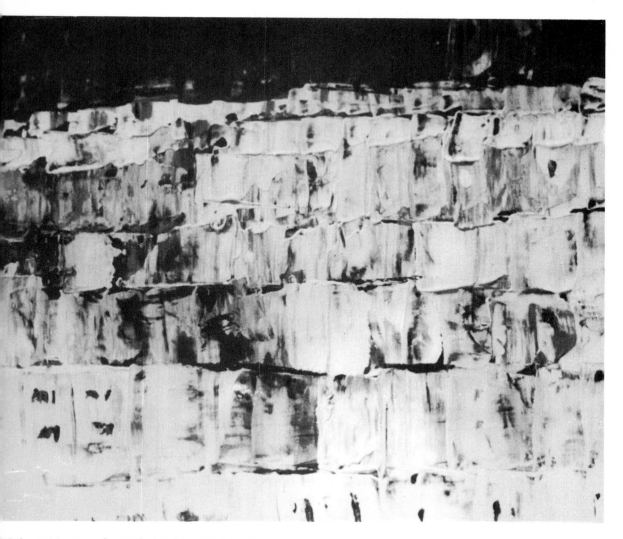

Subtle, yet tense, colour relationships can be stated with the painting knife. This abstraction was painted after a visit to Tunisia with its white and blue, flat-topped buildings

The painting knife is excellent for placing small areas of colour in juxtaposition. Quiet, tense relationships and harmonies of colour can be achieved. The work of Nicholas de Stael contains fine examples of this. The knife comes into its own when used with oil colour to suggest 'singing' grey tones or delicate tones in subtle colour relationships.

Whether attempting to make bold 'slashing' marks, perhaps of a dramatic nature; contrasts of tone or colour; or smaller marks of a more gentle and subtle quality, the painting knife will serve well in answering most needs. The knife lends itself to using paint *impasto* and is therefore most happy with oil colour.

Man sitting at a window, oil colours on white, primed hardboard. The basic set of three knives was used to state contrasts of tone and colour as well as smaller marks of a more subtle quality

Left
Oil colour detail applied with a 10cm straight blade as if spreading butter in short strokes, to suggest 'singing' grey tones and subtle colour relationships

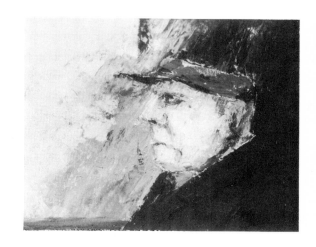

Detail from the same painting. A small, pointed, trowel-shaped painting knife was used to paint detail

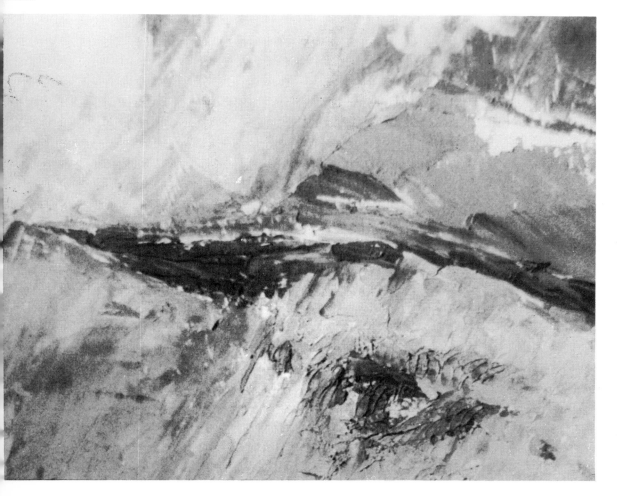

Paint of a runny consistency can also be applied with the knife but this is not common practice as yet, an area to be explored. The use of the knife with water-based media is not as yet established as part of the artist's repertoire and yet it has much to offer. Young artists when painting with a knife, have enjoyed the release from the tighter control demands of a water-colour brush. This is balanced by the need to prepare a composition carefully; the faster-drying water-colours leave little room for alterations during the process of working.

There are certain points to be noted when using a knife for the application of water-colours. Care is needed with fine-pointed knives which may otherwise catch and break the surface (of the paper). Since the blades tend to be thin it may be difficult to control the paint with the more flexible of them — runny paint may be accidently flicked where it is not wanted.

On purchasing a new knife it will be necessary to remove the protective layer of grease put on it by the manufacturers to preserve the blade until it is used. The grease can be easily removed with a household cleaning agent. If this is not done the grease will repell the water-colour and any colour that may remain on the blade will be of an uneven consistency.

The painting knife does not lend itself to the application of colour washes. Perhaps the nearest it will get to a wash is when the surface of the paper is wet first. Then, with the loaded knife held horizontally, pull the 'flat' or back of the blade across the dampened surface. It should be remembered that damage can be caused to the surface of the paper much more easily when it is wet. Care is needed not to scrape the wet paper with the edge or point of the knife.

Working with water colours, liquid paints are easier to use with a knife. This is particularly so when wanting to state the thinnest of linear qualities. Some suggestions for methods of application follow in this section. When carrying a knife loaded with liquid paint across to the area of working, care should be taken not to allow drips to fall

Bernard Doherty painting bolder and freer marks by touching the paper with the tip of the knife held horizontally

in unwanted places. Either hold the knife horizontally or hold a piece of scrap paper underneath until arrival at the target area.

Some methods of application of water-colours with a painting knife:

1 For fine lines and marks — hold the knife with the blade vertically above the paper. Allowing only the tip of the blade to touch the paper move the knife across the surface altering the direction to create the desired effect. Try painting the branches of trees in this way or hair, patterns on fabrics, and reeds and grasses. This method lends itself to all kinds of linear details;

2 For directional, bolder and perhaps freer marks, apply the paint by touching the surface of the paper with the tip of the knife in a horizontal position. Use gentle pressure to pull the knife across the paper;

3 Broad areas such as the thick trunks of trees, sea, cliffs, areas of earth, sky and cloud formations can be applied with the full face of the blade. The paint can be pressed onto the paper with the knife being lifted slowly away or moved across the surface as if spreading jam;

4 Rich textures can be built up by painting layer upon layer of colour. With the application of each layer, move the knife in the opposition direction to that previously made. This helps to knit the layers of paint together and a more permanent picture surface is achieved.

The spreading action can also be used to remove paint while it is still wet. A penknife or stiffer bladed painting knife is good for this purpose. Interesting textures will be seen in the residual film of paint that is left on the paper.

Building rich, textural qualities by painting layer upon layer of colour. The knife is held at an angle to the surface for translucent effects or, with the blade flat to the paper, moved in a spreading action for opacity

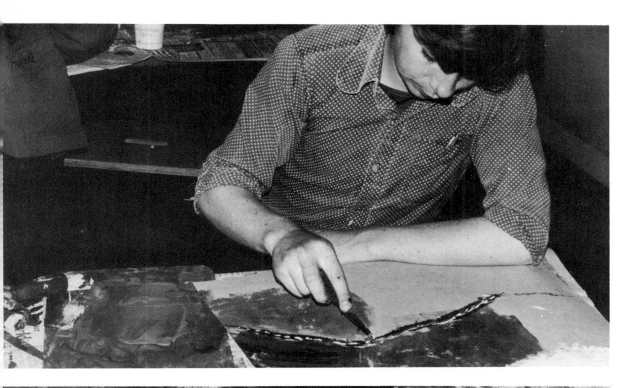

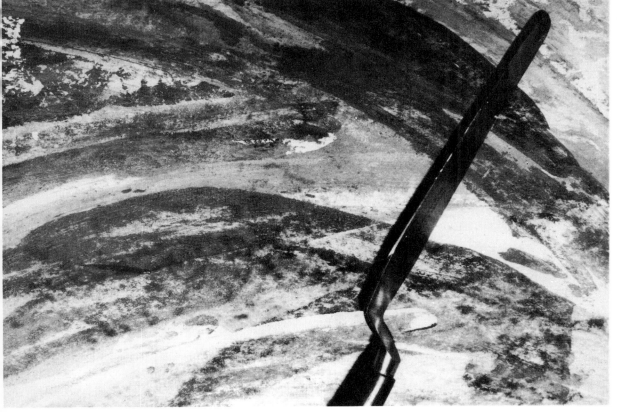

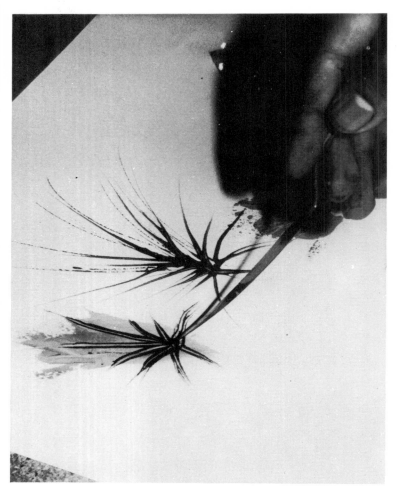

Sgraffito technique with a long, pointed, trowel-shaped blade. Colour can be completely or partially removed dependent on the amount of pressure given

The stiff-bladed knife can be used in the *sgraffito* method of scraping away areas of paint that has dried. The richness of the resultant textures will depend on whether the colour is completely or partially penetrated and on the quality of the colour revealed.

The dry surface of most papers responds well to the application of colour using a paint-ing knife. When paper is wet the surface becomes vulnerable and should it be scratched or dented in any way much more water will be absorbed. This can be harnessed as a way to develop areas of colour darker in tone. The broken surface will then hold more colour and appear more intense. Some interesting effects have been made in this way but it is rather wayward and has limitations.

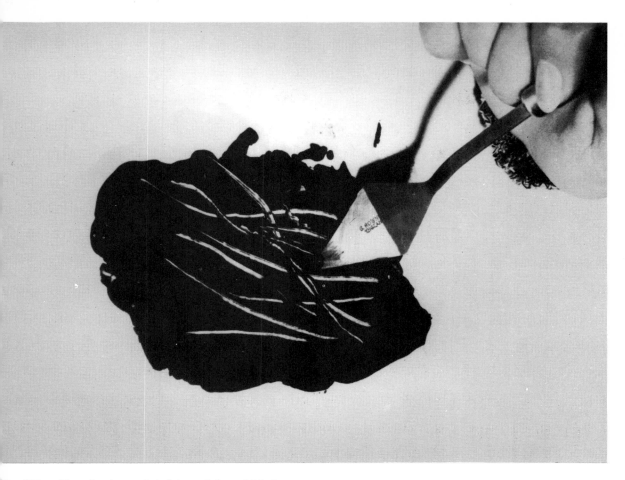

Sgraffito with a shorter, pointed trowel-shaped blade
n wet paint

It is still possible to purchase a good quality painting knife at a reasonable price. But the upward trend in the costs of metal and wood in this decade may make the plastic knife the only economic way of introducing painting with a knife, especially to a class of children. All the methods described can be attempted with the plastic knife with every chance of producing worth-while work. It is less refined than the best metal blades and less able to state the finest details. It will allow the experience of enjoy-ing much of the pleasures from painting with a knife. Other similar applicators to try are old kitchen knives and plastic or wooden spatulas.

In the classroom it is possible for children to produce successful and exciting work using plastic painting knives with liquid tempera colour or poster paints on cartridge or sugar paper. The amounts of the different colours to be used can be put into a bun tin type of palette, having six or nine wells. The palette could be shared by two to four children. It is desirable that each child should have at least two knives; or two children working in the same area could share three different kinds of painting blades. One of the knives should have a straight blade for mixing colours on a palette — *Formica* tile or offcut — before application to the picture ground using a different knife. Cartridge paper may be preferred since it generally has a smoother surface than sugar paper. Nevertheless much good work has been done by children painting with knives on sugar paper at times using its more absorbent nature and rougher surface to good textural effect.

Hardboard is probably the most suitable of all the surfaces available for painting with a knife and children should be allowed the opportunity of working with it wherever possible. It is durable, reasonably rigid to allow pressure when necessary using the knife, provides a smooth surface (and on the reverse a textured surface which is difficult to paint on with brushes), is reasonably priced (use offcuts) and will provide a good white ground with a coat of white primer or emulsion paint. It will provide an opportunity for children to experience a different kind of painting surface.

With forethought and organisation it is possible to have a class of children painting with knives in a controlled and enjoyable situation. As well as learning new skills they will enjoy the opportunity to explore another means of expression. Marks that they make may lead into abstract rather than figurative paintings. These should be accepted as part of the process. As children gain confidence with the techniques suggested their work will become more personal and a controlled form of self expression.

PAINTING WITH ROLLERS

The pleasure of painting is enhanced when using rollers. For the experienced painter and for the beginner rollers have much to offer. They are easy to use, relatively cheap and capable of a wide range of effects. There is a tendency for the beginner to overstate but then it is better to be positive than tentative and indecisive. Using only rollers, it is possible to complete a painting without any loss of detail or tonal quality. Should it prove difficult to state the detail of certain subject matter, a brush or knife could be used. Rollers as paint applicators may well be explored by children in the classroom situation.

Most of the usual painting media can be applied with a roller including oils, tempera and emulsion. Oils are particularly suited to working on a primed hardboard. In school they have a place in the work of senior pupils. Costs and cleaning difficulties when working with an oil-based media may obviate their being used by younger classes. Emulsion paint can be used as an undercoat to oils as well as for painting. Tempera colour in powder form can be used but it is more difficult to achieve uniform consistency than if using ready-mixed tempera colour in liquid or paste form, either of which will facilitate ease of working especially with larger classes.

Rollers (sometimes known as *brayers*) of different sizes can be purchased from most artists' suppliers. Various sizes will be needed. The size of the roller to be used is usually dependent on the size of the area to be covered. Highlights and smaller areas of detail are best achieved using a 4 cm roller; and a 15 cm roller should be adequate for the larger colour areas.

Colour quality can be influenced by quantity. A wide range from translucent to opaque, can be achieved by using a roller with either thin or thick colour. Density of colour can be varied according to the amount of hand pressure applied. With the smaller circumference roller, even opaque colour can only be spread in small quantities and over small areas. This is conducive to a lively picture surface. It should be noted that the greater the amount of pressure used when rolling colour across a surface, the more transparent the colour becomes. With less pressure, colour will be opaque but the area of colour will be broken. Thicker paint — opaque impasto — can be pleasant to use; the pigment adheres well to the painting ground. Colour areas will be patchy if the surface of the roller is not smooth and even. The hard, rubber-covered roller with a wooden core will give satisfactory results with most types of colour. A spongy roller is used to its best advantage with emulsion paint but even then, it can easily become too fully charged and produce a flat effect. The roller needs to run freely and this can be checked before use by looking for an even line along its length. This can be particularly important when working on a hard surface, such as the smooth side of a board when using oil-based media. Interesting areas of colour subtlety can be achieved; the roller is capable of producing translucent effects quite naturally.

Faults that develop with use can be harnessed to effect. The most common are:
1 Warping of the roller surface due to the residue of cleaning fluid after constant use over a period of time. White spirit (the strongest attacking agent) and water are the most likely to be used;
2 Too much hand pressure may force rivets outwards at the ends of rollers;
3 Swelling that may occur at the ends. Colour areas become uneven when using a roller in this condition. The life of a roller will be prolonged if the cleaning fluid is completely wiped off the ends where it tends to collect near the central spindle;
4 The composition, rubber covering of some rollers breaks down after repeated use;
5 When using white spirit the surface of a roller may soften and become sticky. It is worth noting that the solid rubber is much more resistant to the effects of cleaning

Four sizes of roller which together provide a complete basic set. It will be possible to obtain with them all of the marks needed to complete a painting. The smallest is 4 cms wide and the largest is 15 cm. They all have a wooden core to a hard rubber covering

agents. A roller that has become marked or stained or has warped can be used for textural effects. It is obviously more difficult to control such a roller to make precise statements. However it can still have a use and could be stored separately from rollers in good condition. Experimentation will help determine the degree of facility obtainable and the variety of effects that can be produced.

The mixing and rolling out of colours (to ensure an even covering of the roller surface) is best done on a smooth, flat surface. Offcuts of *Formica*, hardboard, wood (must be sealed), metal sheeting or glass will serve. It is important to have more than one palette available. More space may be needed when working with rollers than with a brush or knife. At times it may be desirable to have a separate palette for each colour. Non-absorbent surfaces should be sealed before use — a clear varnish, floor seal, or a pva binder will serve well. A support will be needed for the palettes. The height of it will be determined by whether it is preferred to stand or sit while working.

Any firm surface, well supported, and

Three kinds of tile can be used as palettes: glass, metal and *Formica* offcuts. A separate palette must be used for each colour. Here are two boys sharing colour at the same table, each rolling out a colour that they will both use. The palettes are metal sheets. The boy on the right has more than enough colour on his palette and the roller will slip rather than roll across the surface. An even consistency of colour is desirable

reasonably smooth can be used for roller painting. Hardboard is the cheapest and most practical, especially when using oil colours or emulsion paint. A lightweight card or paper is suitable when using a water-based medium such as tempera colour or block printing inks. Stretched canvas can be used but it is more difficult to obtain translucent effects of colour. Should it be desirable to use a canvas, then a fine-grain cotton is likely to be the most suitable for work in oils. A courser-grained hessian can be used but it is more difficult to control paint

with the roller over the rougher surface. A smooth, hard, non-absorbent surface withstands the pressure needed to roll out thin tones of semi-transparent colour.

Hardboard can be prepared simply as follows: apply one coat of glue-size followed by two to three coats of white under-coat. Alternatively, it is possible to purchase tins of ready-to-use white primer sold by most good suppliers. Two coats of primer should be sufficient.

Smooth surfaces allow a greater variety of effects using rollers, although roughened

surfaces, either ready-bought (for example the reverse of hardboard or masonite) or specially prepared (for example by scraping down an old oil painting) can give interesting results. Surfaces with deep depressions make painting with rollers difficult and are best avoided. Should broken effects of colour or tone be desired the surface should be broadly uneven and depressions shallow, sufficient to allow the roller to work in the depressions where needed.

Most easels are suitable for roller painting if working on a vertical surface. The larger the painting surface, the more it will tend to bend or vibrate when working on it. An easel with a broad support will prevent this. The cheapest and possibly easiest way is to steady the painting board with the hand. An easel takes up less floor space but the surest and most stable method especially with large paintings is to lay the painting surface on a horizontal table, desk or trestle. This can allow for a more varied consistency of colour — liquid colour can be better controlled across the surface.

The use of rollers encourages the creation of broad vigorous strokes. The broadness of roller marks helps to remove most inhibitions and prevents the painting from becoming too tight. This encourages the need to be concerned with the development of the painting overall and not just a part at a time. Rollers can increase the speed of working especially when developing background areas of colour and areas of texture. They cover large areas quickly and easily.

A painting can be built up in different ways when using oil colours, the three main methods of application with rollers are as follows:

1 Thin transparent/translucent layers of paint — the whiteness of the painting ground is important for luminosity (the more layers of paint used, the less the effect of luminosity and more that of opacity);

2 Thick opaque layers of paint. It is possible to paint 'wet over wet' but it is more advisable to wait until first layers of paint are dry;

3 A combination of thin and thick layers

A roller has been coated with an even consistency of paint. On the left is the result of rolling it across a sheet of white card with only little pressure. The colour is impasto and the area broken or patchy. The two areas to the right are the result of giving heavy pressure as the colour is rolled across the card. It is translucent and a more even spread of colour is obtained

of colour.

When working with water-based colour it is important to think first, mix the colour required and place it on to the painting surface without overworking it (unless particular effects of muddiness are required or obscure areas of atmosphere). Too much overpainting deadens colour. Where paint is becoming undesirably muddy it can be scraped off when dry or wiped off with a rag or sponge whilst wet. This often results in a tinge of the colour remaining which can be utilised to good effect. As an alternative, colour areas can be modified by lifting the wet paint off by rolling it over with a dry roller.

When starting a painting, using the translucent method, paint should be rolled out thinly on the palette. It is advisable to work from light to dark (although interesting and often worthwhile effects can be achieved by using lighter colours over dark). Good pressure is needed with the roller to achieve thin layers of colour. Richer or deeper tones will necessitate using the opaque method. The transparent method is most suitable where work is to be within a limited tonal range; light is gained from the white picture ground. When using opaque colour, as layers of paint are placed one on top of each other, it becomes more difficult to control the textural qualities and the covering power of the colour on the roller. Ridges from previous colour areas will catch colour from subsequent rollings.

The more pressure used the nearer to a transparent quality results. Colour has been rolled across a previous layer of paint. The central rolling from left to right is the result of good pressure and allows much of the first layer to be seen through it. Less pressure has been applied to the top area of colour; and the bottom smaller area is nearer an opaque quality as a result of the least pressure

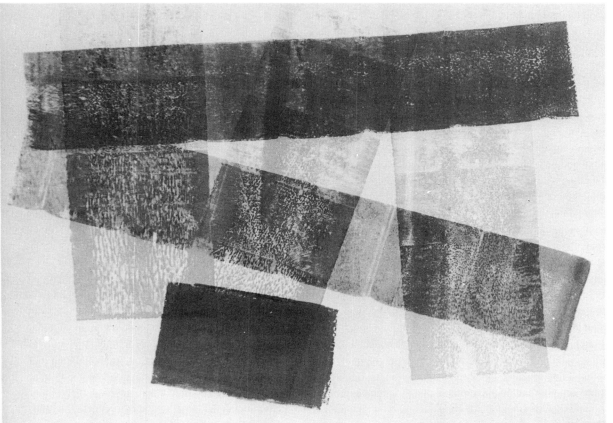

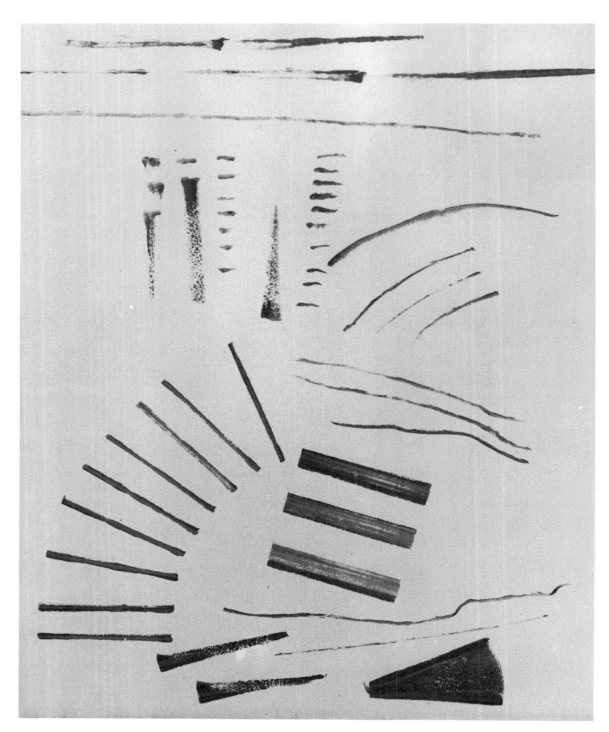

Linear marks made with a roller. Those at the top
resulted from using an end rolled along the card. At
the bottom left are lines achieved by pressing down
the roller along its length. The other marks are varia-
tions on these two main methods

For the beginner, small detail marks may be difficult. It is advisable to be concerned with ideas/subject which require straightforward and larger areas of colour at the outset. In any case it is better to work with the largest rollers first, progressing to the smallest for the final details of a painting. If linear qualities are needed, for example drawing in the basic composition lines before painting or for details towards the end of a piece of work, they can best be achieved by two methods:

1 Holding a roller at an angle so that only an end of it leaves a mark on the picture surface;

2 Pressing the roller down once onto the picture surface and then lifting it to leave a line made along its length.

Much can be done with rollers alone. Some final drawing can be done with the side of the roller. Should further detail and precision be required than can be readily achieved with rollers, then a painting knife could be used. With practice it is possible to achieve a great deal with rollers without recourse to other applicators.

Roller painting can be useful for underpainting when preparing to paint. Personal preferences are important. It may be preferred to use a combination of applicators. As a style of painting develops, so decisions in the choice of painting surfaces, applicators, colour and other equipment will be made.

The natural characteristics of the roller will help to unify a painting. Nevertheless, the use of the roller for painting imposes certain disciplines which have to be taken into consideration. They are:

1 A broad way of thinking;
2 Broad colour areas;
3 Translucent and opaque colour passages;
4 Characteristic marks, for example straight line, wiry line, rectangular shapes of colour for each roll of the roller;
5 Thin overlays of colour;
6 Simplified design or composition.

Success is more likely to result where the work has been carefully planned, with at least one sketch of the subject matter. An artist who starts without any ideas about his subject matter often finds it difficult to keep the work vital and alive. With experience it may be possible to be successful with a minimum of preparation. Starting straight into the painting without preparation requires knowledge of the skill in using media and subject matter and the ability to keep the whole of the painting in mind whilst working on any part of it. Experimental work can be exciting and informative but equally stands the chance of leading to frustration.

Colour and tonal relationships are much easier to assess if the large areas are painted first. A layer of translucent colour rolled over areas of opaque paint in dark shadow areas can help to give a richness and vitality to what might otherwise be an area lacking interest. Roller marks can give a vibrancy to an area of colour.

The particular marks of the roller have their own qualities and have every right to be seen as part of the final picture surface.

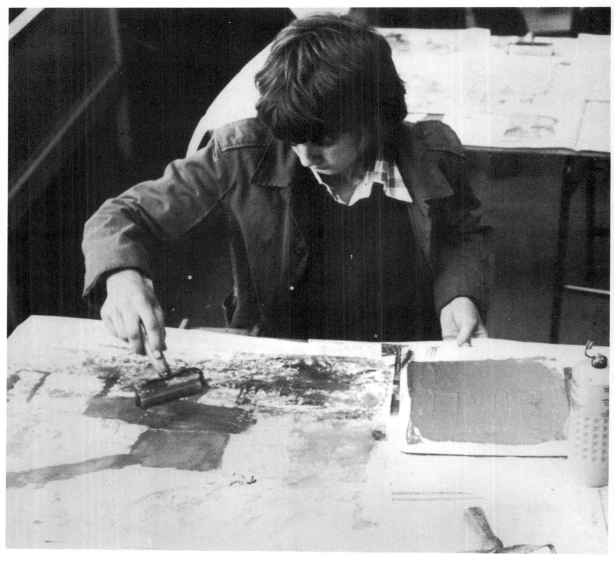

Nigel Kee painting the larger areas of colour. He is
using liquid tempera colour

Choice of a subject for a painting is not all
important, it is rather how pupils use and
interpret the subject that matters most. The
effects that can be achieved with a roller will
suit some responses made and not others.

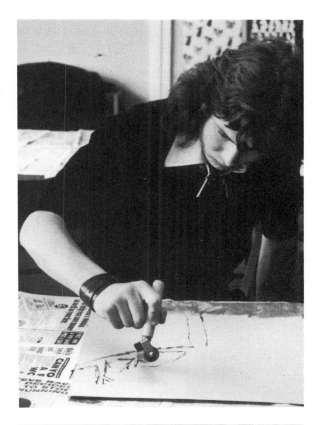

Mark Bourne is seen pressing the roller down along its length to obtain the linear-textural qualities he desires in his landscape painting. (The newspaper protects the table surface)

Drawing with the edge of the roller. Richard Lander drawing the basic structure lines before applying areas of colour

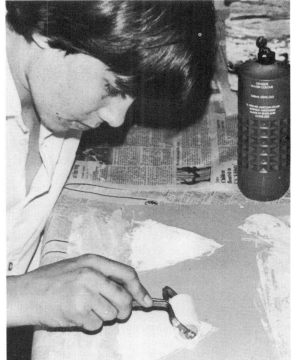

Small rollers for smaller areas. Anthony Porter nearing the completion of the first colour layers to his painting based on a yacht race. The edge of this and of smaller rollers will be used for the details

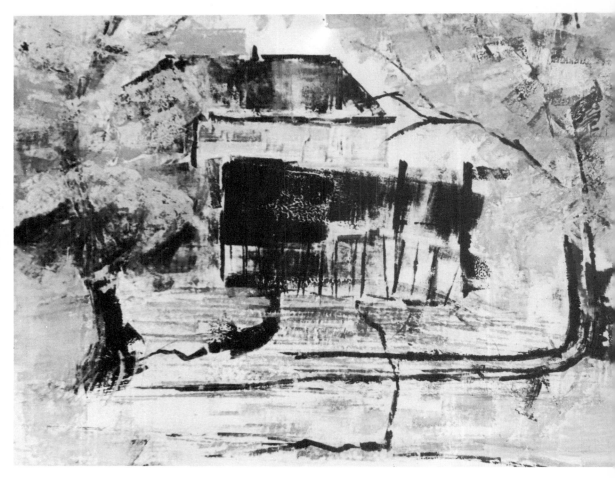

The angles of buildings lend themselves to painting with rollers. This house was seen at the edge of a woodland. A pencil sketch was made on the spot, taken back to the studio and used as the basis for this painting. It is illustrated near completion with only the final details to be added

The roller is highly suitable for stating spatial relationships, as often occur when there is a strong sense of structure in a composition e.g. shapes to be found in built-up areas. Human beings, animals and plant life are more difficult to paint with rollers. It is probably better to leave portraiture until some experience has been gained with other subjects. Much good work has been done in portraiture and figure compositions but it is likely that the beginner will need to use a knife for finer details and subtleties of character. Scale is important here; it is easier to achieve a satisfactory statement painting with rollers if the figure to be painted is large. The straight and symmetrical marks of the roller do not lend themselves to the curves and irregular shapes found in nature but a roller can help to simplify and to relate to each other varied, and, sometimes, contrasting shapes. The smaller the painting the more difficult it will be to achieve detail. Marks from the roller will help to give a sense of unity and strength to the subject matter whatever the scale.

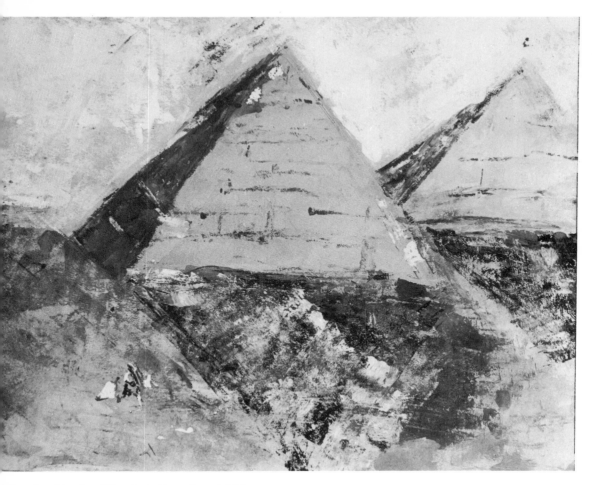

ollers tend to simplify what otherwise might be
onfused. Broad statements have been made in this
ainting of pyramids with two small figures in the
ft foreground

The character of trees and plant life can
est be done by painting within the shapes
sing the rollers in different directions to
emove the linear effect that comes from the
oller edges and to give a sense of continuity
o sky and landscape. Opaque and impasto
ighlights can be rolled over darker tones
vhere desired. The subtleties of shape and
olour in vegetation would best be put in
ast, beginning with the lightest. A tree skele-
on or structure stated first, can then have
oliage added later and a more convincing
ense of growth is achieved. Plant forms,

particularly flowers, are not easy to paint
with this technique. The smallest rollers
will be needed for the delicate qualities of
certain flowers. Large paintings of larger
blooms such as sunflowers and giant dhalias
are more likely to be successful.

The use of the roller facilitates the possi-
bility of giving underlying structure to the
painting. The roller gives a positive decisive
mark, a straight line can be achieved with
confidence. The line along the length of the
roller is present before it is made on the
picture surface. Strong structural lines —

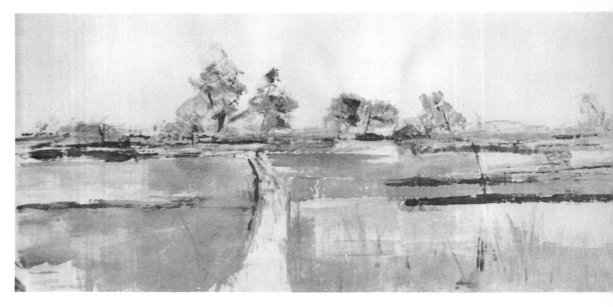

Large areas of sky and foreground were painted
and when dry the finer drawn lines were applied. The
trees were stated using a 4 cm roller; the blurred
appearance to give the sense of distance was obtained
by placing the edge of the roller onto the paper and
twisting it slightly. The painting was completed in
two hours fifteen minutes

uprights, horizontals and diagonals — can be
readily achieved. Textures of fences, walls
and windows can be painted with a smaller
roller. Large areas of sky or the foreground
are more easily and quickly achieved with a
large roller.

The difficulty of working on or against
wet surfaces means that careful consideration
must be given to the programme of work
so that colour once put on is as correct as
possible. A heavy build-up of wet paint will
cause blurred images and confused planes.
Where colour is wrong or unsatisfactory
it is better to scrape it off with a knife and to
apply a fresh colour.

Areas of colour may have to be scraped
off to obtain certain tonal qualities. Light
tones can be realised by scraping off wet
paint with a knife.

It is important to have a logical working
process. The following step-by-step system
is known to be successful:

1 Drawing in the basic lines of the composi-
tion. Personal preference will determine
whether this is done with the edge of small
rollers, charcoal, pencil lines or brush;
2 Light lines/marks to ensure proportions
are right;
3 The main forms can be indicated with
straight lines made from along the length
of the roller;
4 More delicate forms can be 'drawn' with
thin lines produced by the end of the
roller;
5 Application of large areas of colour with
the larger rollers;
6 Smaller detail areas to be applied with the
smaller rollers;
7 Final details using the ends of the smaller
rollers.

It is important to work logically from light
to dark tones or vice versa. There is a ten-
dency for the whole tonal quality to be too
high if light tones are placed first. Neverthe-

less, a clear sense of development can be achieved. Alternatively, stating the dark tones first is a safer process in most painting techniques, when highlights could either be successfully stated using paint *impasto* or by scraping away areas of colour to allow the white ground beneath to show through (*sgraffito*). It is advisable to try both processes; it is really a matter of personal preference.

The first colour statements made with a roller should be areas of thin paint all over the picture surface. The larger shapes can then be stated, after which many of the smaller shapes will fall into place. Layers of opaque colour applied over the first semi-transparent areas of paint bring the painting to a satisfactory conclusion.

The degree of control children will exercise is dependent upon a sensitivity to the nature of the rollers and the necessary practice in their use as paint applicators. The different qualities of marks that can be made with rollers of various sizes, different kinds of qualities of paint and the wide range of picture surfaces available, can be exciting in themselves. If these marks are harnessed and organised they can be used to produce successful abstract paintings.

Children can gain satisfaction from completing paintings with rollers in a short space of time. This should not be seen as the only reason for using them. Speed of working and 'one-off' success obscure many of the possibilities. Practice and experiment cannot be overstressed as important to feed well-thought-out and prepared compositions. The broadness of mark and sense of spontaneity evident in much of the work painted with rollers can be preserved, whilst developing the skills and sensitivity necessary for more intricate and subtle statements.

Consideration has to be given to the size of classes, organisation, availability of materials and costs. Try painting with:

1 A choice of two rollers, one 4 cm in length and one 15 cm. (Where solid rubber rollers are not possible, the hard, rubber-covered roller with a wooden core will give satisfactory results);

2 Liquid tempera colour or water-based printing inks;

3 Palette; a *Formica* tile or work directly on a formica-topped table. Either can be easily cleaned;

4 Palette knife for mixing the colours required;

5 Cartridge paper or sugar paper;

6 Old newspapers to protect working surfaces where necessary and rags for cleaning purposes. If a class of children is divided into groups of two — four they can share equipment. But wherever possible each pupil should have at least one palette and two rollers. Investment in sufficient good equipment will be money well spent. If used with care and cleaned and stored properly after use it will serve well for many working sessions.

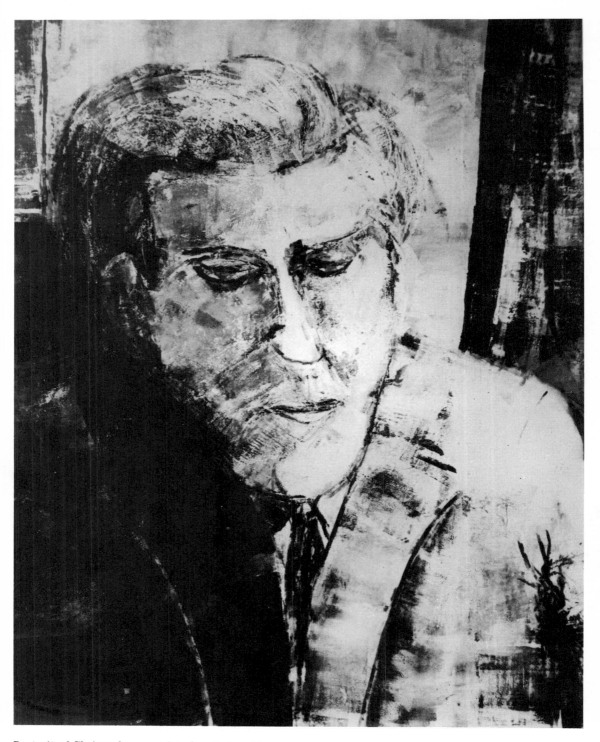

Portrait of Christopher completed entirely with rollers. Large areas were painted first. The process went from light to dark. Final details were applied with a 4 cm roller and included *impasto* highlights

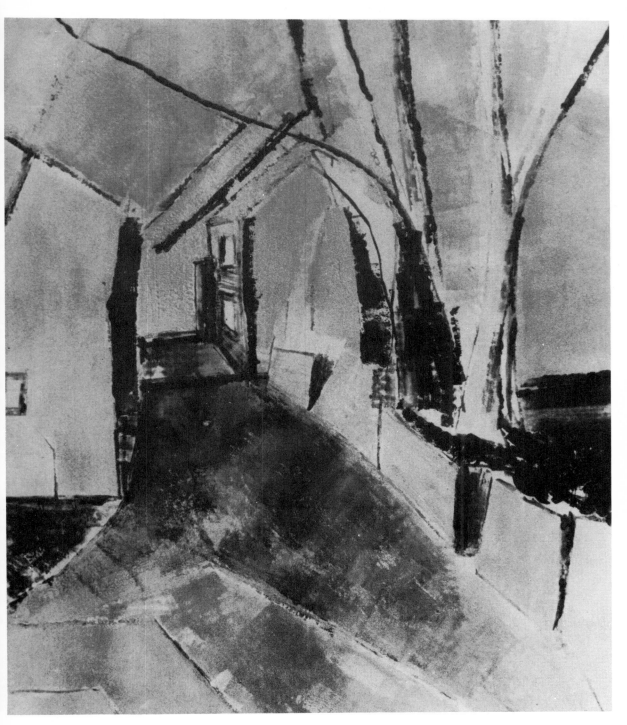

Back Street in St Mawes by the author. The first
stages of this painting have been completed. A basic
structure using the edge of a roller to make a linear
drawing was established first. Colour areas were then
applied. All is ready for details to be added and
characteristics of buildings, trees and foliage to be
developed

SPRAY PAINTING

The main advantage of spray painting is the speed with which it is possible to cover a large area with an 'even' coat of paint and a good degree of colour intensity. This would be much more difficult to achieve with a paint brush, palette knife or a roller. It can be used to create diffuse atmospheres, tonal subtleties, and interesting effects of colour mixing by spraying one colour over another in open layers of paint. When used with masks, strong contrasts of shape, tone and colour can be made.

Variations in the kind of spray are due to three main factors. The type and the consistency of colour used, whether it be ink, tempera colour, emulsion or oils will influence the result. Different applicators, such as spray diffuser, spray gun or air brush can determine the quality and refinement of spray achieved. With experience the right choices will be made but skill and knowledge will also affect the quality of the painting.

For translucent effects in a painting, inks and transparent water-colours are appropriate. Opaque colours such as ready-mixed liquid tempera colour will give good coverage as well as colour brilliance. To achieve the latter when spray painting, it is important not to attempt subsequent colour applications while the first coat of paint is still wet, since this often results in a muddy colour effect, especially if the overpainting is with a complementary or contrasting colour. Spray painting over paint that is dry is a more certain method. Emulsion colours are versatile in that a certain degree of translucency can be achieved when applying thinner coats of paint; yet they are probably most often used for their opaque qualities.

Much here is dependent on the consistency of the colour used and the degree of spray given in each application. Paint that has been thinned with an appropriate solvent (with emulsion paint use water) will have less covering power than one that is used neat. In most circumstances it is better to give two or three thinner applications. This avoids pools of paint building up or colour running into unwanted places. The consistency of the colour used will also be directly related to the size of aperture of the spray gun or diffuser nozzle. Colour that is too thick will clog up the apperture and cause frustrations and cleaning problems. Care should be taken to clean all working parts thoroughly immediately after use. This is also important when using inks. All of the colours mentioned so far in this section are water-based. This makes them particularly useful in school since they are relatively easy to clean and colours generally dry faster which makes storage easier.

Nevertheless, oil colours can be used in spray painting and they have an advantage over most water-based colours by holding their colour properties on drying. Thinned with pure turpentine, they can be used safely with a spray gun or diffuser. It is not advisable for oils to be used with a mouth spray diffuser. The colour quality obtained after spraying will tend to be translucent because it will have to be thinned to a considerable degree to allow it to pass smoothly through the nozzle. Degrees of opacity can be developed with successive applications. Oils usually take a much longer time to dry than water-based media. The thinning process will reduce the drying time but considerable delays will be experienced to ensure the colour is dry before spraying a successive layer of paint. An artist working in a studio or room adapted and used only for creative work may well wish to explore and employ oil colours. The choice of colour will be influenced by the place of work and the purpose. For most situations, particularly in school and at home, the demands of spray painting can be successfully answered using inks, liquid tempera colour or emulsion paint.

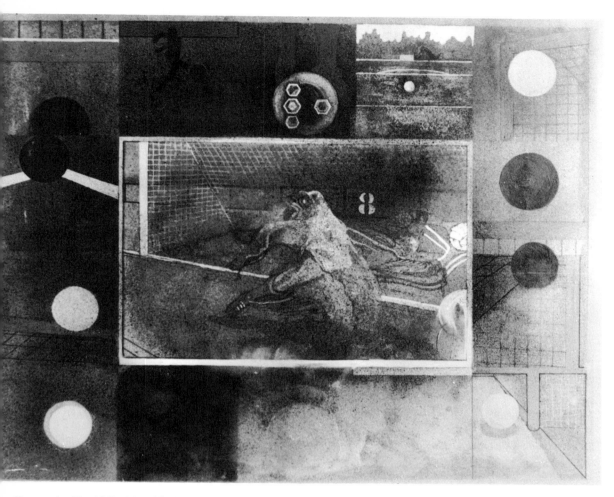

Goalkeeper by David Stubbs, 1973. The drawing was done first. Then spray was added, areas being masked off as the layers were built up. Subtle gradations of colour have been achieved by the number of layers sprayed with different areas masked off for subsequent applications

The quality of spray possible will be dependent on the choice of diffuser or gun to be used. A sophisticated and expensive air brush will offer the widest range. There is a variety to choose from. Most air brushes have an adjustable nozzle which allows the density of spray to be altered. The finest spray (or smaller points of colour) will allow treatment of restricted or smaller areas/shapes which require a measure of detail; subtle and gentle atmospheric effects and distance — aerial perspective — in landscape; and colour mixing by spraying paint over previous applications allowing the eye to complete the sensation of colour mixing — much the same as Seurat with his 'points of colour' in his *pointillist* technique. (The *pointillists* calculated the size of colour points to be placed in juxtaposition, applied with a brush, to achieve the desired colour sensation. With spray painting it is possible to get near to a similar colour sensation without the same degree of precision). In this context it would also be worthwhile to look at the work of living artists employing similar techniques — of spray painting —

A spray gun with adjustable nozzle, useful for varying the quality of spray and for colour-mixing optically

for different purposes. Since the early 1960s Bernard Cohen has used spray painting in his work, for example *Red One*, 1965, and *Fall*, 1964, both in the Tate Gallery, London. David Stubbs, whose work is illustrated in this book, frequently employs spray techniques and has been particularly successful in achieving subtle colour gradations. In Ian Stephenson's paintings a speckled drift of pure colour turns out, against all expectation, to define form and space, and to negotiate with light in ways not explored by any other painter.[1] (See Stephenson's series *Easement*, 1975, Arts Council Collection; and his *Panachrome*, 1964, Tate Gallery, London).

An adjustable nozzle will allow the densit of spray to be changed from the finest t coarser and larger dots of colour. The latte will be useful for the treatment of larg areas of sky, sea and landscape; action figures, turbulent seas, cloudy windswer skies; and intense colour areas, as whe concerned with near objects in paintin employing aerial perspective. Colour mixir may be more difficult to accomplish wit larger dots of colour. It would be necessar to stand further back from the finishe painting than may be possible in most situ tions.

The varying degrees of spray density ca be directed for certain textural qualities

[1] John Russell. Private View 1965. Page 237. Nelson. See also the catalogue of the exhibition of Stephenson's work at the Hayward Gallery, London, March/April 1977

detail. Most of the smaller areas of detail will probably be painted with a fine spray, but certain subjects will require texture or colour brilliance which can only be achieved using the coarsest of spray applications. Textures of foliage, clothing, walls and rock structures tend to be in this category. The demand for differences of spray density may only be determinable in the event. Practice and experiment are necessary to be able to answer demands as they arise.

A good quality air brush or spray gun will give a uniform size of colour dot. Uneven applications of spray are all too often the result of using a less refined spray gun or a diffuser operated by the mouth. This at worst, approximates to the disparity of size of colour dot obtained by spraying paint with a toothbrush, which is much more difficult to control.

Some of the most sophisticated air brushes require a suppressor and a storage tank or a cylinder of gas. The use of gas has enabled manufacturers to make available models that are simpler to use and cheaper. These make spray painting a more likely proposition in school. Reeves produce the *Badger Spray* — to be used in conjunction with an aerosol propellant — which is successful in small scale work. The *Jet Pack Spray Gun* obtainable from E.J. Arnold, is a self-contained spray gun using an aerosol action. E.J. Arnold recommend that Arnold *Colourcraft* emulsion or poster paint be put into the paint container and sprayed to cover a surface quickly and evenly. The gun is supplied with power unit and container.

Alternatives to the relatively expensive air brush are a spray diffuser, garden insecticide sprayers and aerosol sprays. The mouth spray diffuser has its limitations (quality of spray is difficult to control) but will give satisfactory results in early attempts. Aerosol sprays tend to be expensive and are also difficult to control. Improvisations could be tried, for

This sculpture in polystyrene (on a steel rod axis) has been sprayed to accentuate the form and texture, using a spray gun. Variations in density help to enhance textural qualities. Aspects have been emphasised by holding the spray gun so that the spray is directed at an angle. Gradations in light and tone help to make the form of the work convincing

instance by using perfume dispensers with rubber bulb attachments. For his picture *Generation*, 1962, (in the possession of the Kasmin Gallery London, 1973), Bernard Cohen used a scent spray '. . . . which necessarily made his line relatively wide and soft-focus. Spray techniques have been central to his work ever since'. [2] When an atomiser (a diffuser that does not provide for the adjustment of spray) is being used, the result is usually a coarser texture. Once the kind of spray produced by a particular instrument is known, it can be used for special qualities and effects in a painting.

[2] Richard Morphet. Introduction in the catalogue to the exhibition of Bernard Cohen's paintings and drawings 1959-71 at the Hanward Gallery, London. 6 April - 14 May 1972

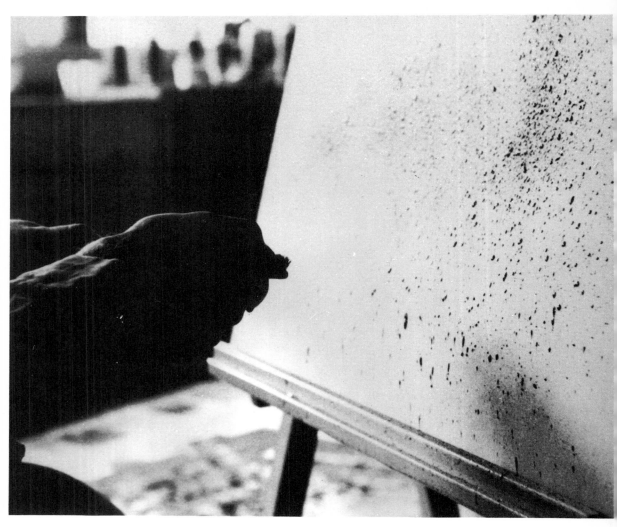

When using a toothbrush, the movement of the thumb
(or implement) across the bristles should be in the
opposite direction to the spray. Different textures
will result from changing the angle of the spray and
the speed of movement across the brush

An air brush and a compressor are being used here to
establish an even texture on the hat and on parts of
the clothing of the female figure to the right, without
using a mask. Light, thin applications of paint were
made and allowed to dry before subsequent layers
were applied

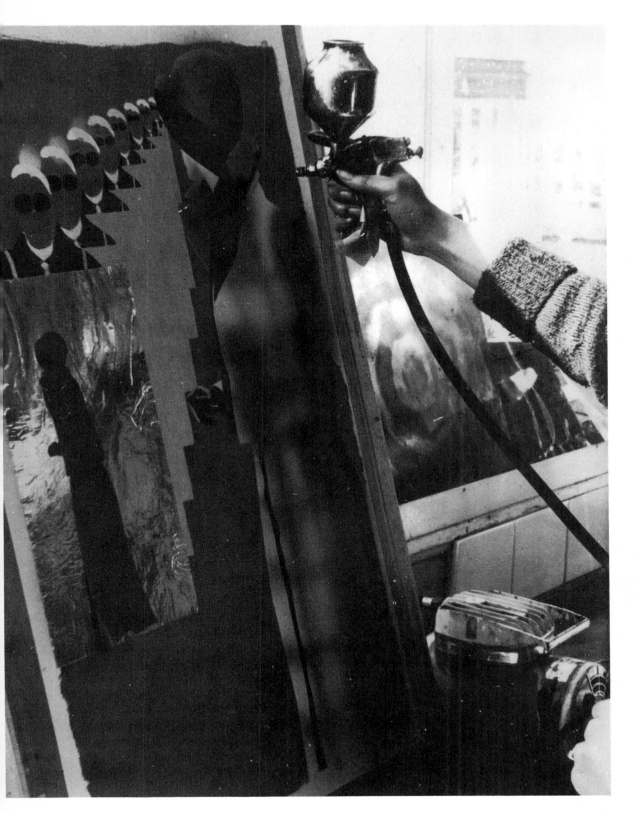

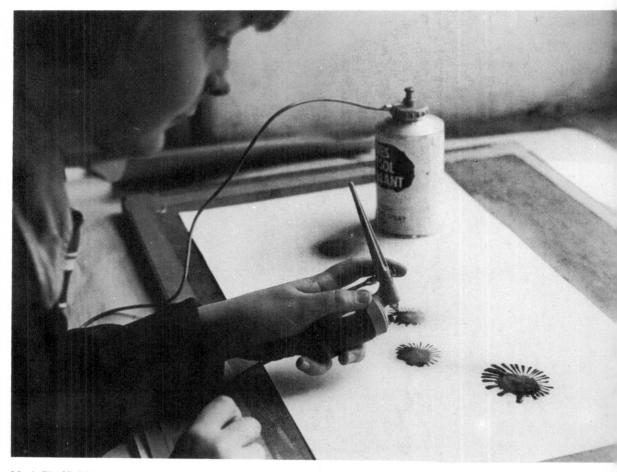

Mark Sheffield is giving only short bursts of spray whilst holding the nozzle close to the paper. The quality and length of the tentacles of colour radiating from the central mass or core of colour can be varied according to the distance of the nozzle from the picture ground and the length of the spraying time

Skill and knowledge in the use of a spraying instrument are important to control the work in hand and to achieve satisfactory results. Spray guns are not readily easy to control, especially to achieve small areas of definition. It is essential to read manufacturers instructions carefully before painting. Degress of refinement in the manufacture will require different measures of control and skill in use. Some delineation can be achieved dependent on three main points:

1 Size of the spray nozzle. An easily adjustable nozzle is preferable;

2 Air (or gas) pressure. Too little pressure and the paint may appear as disparate blobs. Too much pressure and a sudden spurt of colour could be a disturbing surprise. Test the flow of paint spray before applying to the picture surface;

3 Distance of the spray nozzle from the picture ground. Held too near the picture surface the paint will collect and lead to puddles of colour. The further away the spray gun or diffuser, so the dispersal of colour is increased over a wider area, usually with a resultant loss of colour intensity.

If an even covering or dispersal of colour is intended it is essential to move the nozzle parallel to the surface to be painted. A common mistake is to swing the nozzle in an arc leading to an uneven covering and variations in colour density.

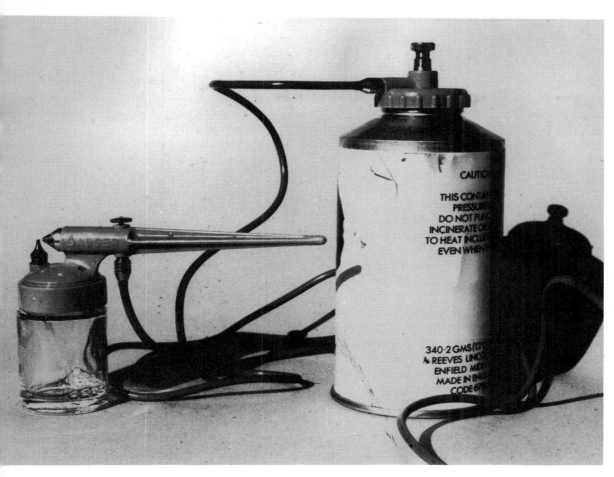

The little valve at the top of the gas propellent is
turned down to produce pressure for spraying paint
from its container

PAINTING GROUND

PATH OF NOZZLE

CORRECT

PAINTING GROUND

PATH OF NOZZLE

INCORRECT

Spray painting should be carried out in a well-ventilated room. Invisible particles of paint enter the atmosphere and it is difficult, if not impossible, to ensure that all the paint goes onto the picture surface. Try to set up a corner of a room which is shielded or partitioned off for spray painting. If this is not possible, a large cardboard box would suffice for smaller work. When the weather is fine, try painting out of doors. With reasonable precautions and common sense, spray painting is quite safe and can be immensely enjoyable.

It will be worthwhile to give attention to the use of paint thinners and cleaners (solvents) in more detail. Manufacturers' advice is the best guide. This may be found in the instructions accompanying the spray guns and air brushes, where paints are often recommended. Paint manufacturers publish advice on the use of their products and usually state the best thinner to use. When using inks, again it is important to understand the nature of the media. Waterproof inks — most calligraphic and indian inks — tend to clog channels as they dry. It is especially important to clean equipment after a working session with a spray gun. Simply, this means using water for water-based media and white spirits or turpentine substitute for oil-based paint. Pour any unused paint back into its container for storage and wash through the working parts of the gun and the paint receptacle with the appropriate solvent. When all traces of paint have been cleaned off it is a good idea to wash through the working parts of the gun with warm water and soap. Since soap tends to leave a greasy film, finish off the cleaning process by rinsing with warm water.

When using spray there is no sense of calligraphy, of a personal contact that comes from applying paint by a more direct process such as painting with fingers. Many artists object to spray painting as the product of a mechanical process. The final results are considered by some artists and critics as too clinical and removed from the necessary human touch. Yet the choice and interpretation of subject matter is still an individual concern. It is possible to achieve colour harmony and intensity, the result of a personal expression of colour awareness and sensitivity. A personal attitude and sense of atmosphere can be developed. It is possible to state strong contrasts or to paint subtle changes of tone by using masks working progressively from the extremes, light to dark or vice versa.

The possibility of spray painting achieving textural harmonies has not been fully explored. So far it has been noted for its suitability to state contrasts. Masks facilitate sharp contrasts between clean cut shapes and diffuse areas of colour. The sharp-edged imagery of commercial art is often achieved by masking areas to spray techniques. Exciting and dramatic imagery has been achieved in this way. The contrast in texture can be used to good effect to focus attention on certain aspects of a design or composition. This method has been used by Ian Stephenson and Jules Olitski[3] whose use of spray has become a complex and highly developed process. Contrasts of gloss and matt paint are an extension by Olitski of the contrast of spray against masked areas, for example, in his *Doulma*, 1966. His work contains a variety of methods of applying paint including sponges, rollers, pouring and spattering paint and in his use of spray painting are some of the possibilities of textural harmonies. Once children have some experience with the processes they could be encouraged to combine them in the work they do. This could be particularly important towards widening the scope for textural contrasts and harmonies.

Masking techniques are useful and at times important to successful spray painting. It is essential to mask off all areas of a painting that are not intended to receive paint. This may be done in a variety of ways. The most usual are using masking tape, *Sellotape* (tends to buckle and warp when wet with paint) and templates cut to mask particular shapes.

[3] *Footsteps of a Master: the Jules Olitski Retrospective.* Ken Carpenter Studio International September 1973

The closer the spray nozzle and the less the air or gas pressure, the coarser the spray. Adjustments to these factors will influence the quality of spray. An even quality of colour was applied quickly before using masks, shapes cut from magazine pictures have been used to create superimposed imagery for this composition *The Accident* by Harvinder Soor

Some of the different ways of making templates are as follows:

(i) Perhaps the simplest is the found object. The shape of the object(s) is the most important element of its character in this context. A composition could be arrived at by arranging a number of found objects similar in outline to produce a family of shapes or a single object could be repeated, moving its position for successive sprayings perhaps superimposing the image more than once. Repetition of the unit (found object) can lead to complex designs built up by applying several colours and overlapping the shapes. In this way new shapes will be created by the overlaps and between shapes. Try using found objects with open areas, maybe a mesh or grid or discarded computer cards, for textural purposes. Pieces of fabric such as organdie and hessian could be placed on the picture surface and sprayed so that the negative or open areas of the fabric become the positive marks in the painting. Pieces of machinery could be tried amongst many other possibilities to be found in everyday use, such as scissors, safety pins, and pastry cutters;

Assassination, 1976, by David Stubbs. Using a stencil and spray gun, Kennedy's head has been superimposed on a painting of the cavalcade. The tree at the top left of the picture was built up using vaseline as a mask with ink sprayed over it. The procedure was repeated using various coloured inks. Cardboard was used as a mask for the large background areas

(ii) Masks can be made quite quickly by tearing shapes from paper. Old newspapers are perfectly good for this purpose. But care will have to be taken to ensure the paper stays in place whilst spraying. Masks must be attached firmly to ensure contrasts and clear edges to shapes. Paint particles will find their way under masks that are not fixed in position. The effects of colour seepage can be useful, they can lead to tonal and colour gradations where areas of paint merge together. Other papers that could be tried are cartridge and sugar (construction) papers; unwanted drawings could serve well.

Torn fabrics are worth trying for the interesting edges to shapes that can result, bearing in mind that the thinner the fabric the more quickly it will become saturated with colour, which will eventually seep through onto the picture surface (obversely, the thicker the fabric the more difficult it will be to tear by hand). Papers in general are more successful for this kind of work. It should be remembered that they tear more easily in the direction of the grain, though it may be necessary to tear across the grain to collect a variety of shapes.

The most common method of fixing thin

This painting is a combination of spray, brush and collage techniques. The use of washers to mask the plasticell sheeting (polyurethane foam) from the spray contributes to an exciting imagery in which the circular motif is repeated throughout giving the composition a sense of unity

Neil is cutting a mask of a butterfly shape from a piece of card

or delicate masks in position is by using dressmakers' pins. This presumes the picture surface to be paper supported by a drawing board. The masks can then be pinned through the paper to the board; a tiny pin prick will remain, but barely discernable. Other methods include drawing pins and paper clips. Thin paper masks can be wetted to adhere to boards or to card that is thick enough not to warp with a thin film of water from the mask. Small pieces of adhesive tape can be attached at one or two points of the mask or cut to shape to hold down the complete perimeter. Masking tape is effective and easy to remove from most surfaces after spraying. Another method is to stick the mask to the picture surface using a rubber solution;

(iii) An extension of the use of fixing materials is directly applying them to the picture surface as masks. The late Arthur Guptill[4] suggested the use of rubber cement. It could be either applied from the tube or diluted with benzol and brushed on. This technique is advisable with water-based colours only. When the sprayed paint has dried, the rubber

[4] Arthur L. Guptill *Water Colour Painting Step-by-Step* Pitman 6th printing 1975

cement can be peeled off or rubbed away with a finger. Alternatives could include plaster of paris, flour paste and paraffin wax using a *tjanting* (used to apply wax in Batik work). When the spraying is complete the wax could be removed by ironing under brown paper;

(iv) Designs cut from paper or thin card usually lead to precise, clean edged shapes. The easiest is a simple outline shape. Paper could be folded and a shape or shapes cut from the fold which is then opened out and used as a mask. Holes punched or cut in a paper or card shape, and discarded computer cards or factory 'clocking in' cards, could be tried. Shapes can be cut from self-adhesive materials such as *Transpaseal*, vinyl wall-papers or pvc sheeting; and from adhesive tapes such as masking tape. The picture surface should be chosen carefully to ensure that its texture will not prevent the chosen material from adhering to it; and also that it will allow the mask to be peeled off easily after spraying. As with torn paper masks, cut out shapes can be repeated and super-imposed. Costs can be kept down by using off cuts or remnants of adhesive materials;

Further sprayings of different colours can be applied after rearranging the cut out shapes. This is the work of a fourteen year old girl

(v) Threads and string of different lengths and thicknesses can be tried separately or in combinations in the same painting. Very fine threads should be avoided since their positions are likely to be disturbed by the force of the spray. The thread or string must be dry before moving it from its position as a mask. Various arrangements could be tried with subsequent applications of paint with different colours.

The most common causes of smudging painted areas are easily avoided. Masks should be left in position until paint has dried. Paper or card masks should be fixed into position close to the picture surface to prevent them from twisting and warping and to stop paint from seeping underneath. An alternative is to use water-resistant masks. Paper and card can be waterproofed by coating them with wax — candle wax or wax crayon, varnish or fixatif.

Masks can be quite elaborate and can take a long time to prepare. Keep cut outs at least until the painting on hand is complete. They can be useful for spraying again over the first application perhaps a superimposition with the shapes shifted slightly to give a double imagery. The 'negative shape' might become a positive for spraying a different colour around the first shape. Masks could be used in future work such as collage; a design could also incorporate shapes cut from previously sprayed papers, cards and fabrics.

In conclusion, the following is a possible method of working. Prepare by bringing together all necessary equipment. To ensure controlled careful work it will be necessary to make a drawing. This may be of the main lines of a design or composition, drawn in pencil; or a careful drawing for a mask before cutting out with scissors or knife. This kind of preparation leads to good control especially when working with a preconceived idea of the end result. Nevertheless there is much excitement and satisfaction to be gained from building a painting in progress, the end product resulting from the work in hand. Should a drawing be made on the picture

Children's Growth Through Creative Experience: Art and Craft Education 8-13, Schools Council, Van Nostrand Reinhold, New York, 1974
Education of Vision, edited by Gyorgy Kepes, Studio Vista, London, 1965
Visual Thinking, Rudolf Arnheim, Faber, London, 1970

Appreciation

Art and Illusion, E.H. Gombrich, Phaidon Press, London, 1960
Towards a Psychology of Art, Rudolf Arnheim, Faber, London, 1966
Movements in Art Since 1945, Edward Lucie-Smith, Thames and Hudson, London, 1969
A Concise History of Modern Painting, Herbert Read, Thames and Hudson, London, 1967
Max Ernst, John Russell, Thames and Hudson, London, 1967
Sidney Nolan: Myth and Imagery, Elwyn Lynn, Macmillan, London, 1967
Antonio Tapies, Vera Linhartova, Thames and Hudson, London, 1972
The Work of Jean Dubuffet, Peter Selz, Museum of Modern Art, New York, 1962
Art — Action and Participation, Frank Popper, Studio Vista, London, 1975

Suggestions for film strips

The Century Series
 Hidden Wonders Through a Microscope
 Visual Stimulus
Focal Point Filmstrips Limited
 35 Cavendish Drive Portsmouth
The Seeing Eye. Adviser Gordon Bradshaw
 Part 1 Elements of Design
 Part 2 Design in Nature
 Part 3 Man-Made Design
 Part 4 Accidental Scene
Focal Point Filmstrips Limited
 35 Cavendish Drive Portsmouth
Changing The Face of Things. Compiled and annotated by John S. Beswick
 1 General Introduction
 2 Effects of Pattern and Colour
 3 Effects of Reflection and Light
 4 Unification, Emphasis and Division
 5 Camouflage and Display
 6 Design and Surface Qualities
Visual Publications
 197 Kensington High Street London W8
In Sight. Compiled by James Bradley, Sylvia Burns, Ralph Hurst and Pat Radley.
 1 Shape
 2 Organisation
 3 Focus
 4 Distortion
 5 Structure
 6 Movement
Visual Publications
 197 Kensington High Street London W8

SUPPLIERS

Visual Aids

Athena Reproductions 76 Southampton Row
London WC1
Prints and reproductions
Catalogue available

BBC Schools Broadcasting Council Radio
Vision — film strips
(Can be made into slides) and radio series
(can be taped)
Teacher's notes available

The British Film Institute 81 Dean Street
London W1
Film strips, cine film and slides

Educational Publications Limited East Ardsley
Wakefield Yorkshire
Slides, film strips and wall charts
catalogue available

Visual Publications 197 High Street London
W8
Sets of film strips catalogue available

Winsor and Newton Wealdstone Harrow
Middlesex
Filmstrips for sale and hire, slides and wall
charts. Catalogues available

A Zwemmer Limited Charing Cross Road
London WC2
Prints and Reproductions

General plus particular items involved

E J Arnold and Son Ltd 10 Butterley Street
Leeds LS10 1AX
The Jet Pack spray gun Arnold colourcraft
emulsion paint Finger paints and finger
painting paper

Crafts Unlimited 21 Macklin Street London
WC2

Dryad Northgates Leicester, LE1 4QR
Rollers, brayers and printing inks

Hunter Penrose Ltd 7 Spa Road London
SE16 3QS
Air brush and Compressor

Margros Limited Monument House Monument
Way West Woking Surrey

Reeves and Sons Limited Lincoln Road
Enfield Middlesex
The Badger spray

George Rowney and Co 10-11 Percy Street
London W1
School of Art Oil Colours
Primer

Gerald Stains Ltd Puttridge Works Fernbank
Road Ross-on-Wye Herefordshire
Burgess Electric Sprayer

Winsor and Newton Limited Wealdstone
Harrow Middlesex and 51 Rathbone
Place London W1
Rollers

INDEX